Something Close to Music
Late Art Writings, Poems, and Playlists

David Zwirner Books

ekphrasis

Something Close to Music
Late Art Writings, Poems, and Playlists
John Ashbery

Selected by Jeffrey Lependorf

Contents

Editor's Note

Jeffrey Lependorf

This volume gathers together poems by John Ashbery (1927–2017) with a selection of his contemporaneous art writing, all published during the last twenty years of his life. In addition, because Ashbery loved music and always listened to it while writing, there are playlists of recordings from these same years culled from Ashbery's personal library.

Some of Ashbery's poetry is often described as ekphrastic. Though rather than writing a poem based on or inspired by the content of an artwork or a piece of music, he engaged with the experience of seeing, or hearing, it and with how the artistic strategies employed offer ways of thinking—both about it and through it. Many of the observations in his art writings also provide keys to how we might think about his poetry. In his piece on the painter Frank Faulkner, for example, he writes:

> The outlines are clear, in general, but there are stray paths and counter-proposals that throw us off-balance, even though on closer inspection they, too, seem to be traces of a schema so large that we see only fragments of it.... Meanwhile what counts for us is the gorgeous and seemingly arbitrary fluctuations of a visible dream whose roots are nonetheless deeply anchored in reason.[1]

Ashbery's poetry provides similar pleasures. The tantalizing promise of a narrative logic underlying his fragmentary dreamscapes equally draws us in and eludes us, leaving us with an experience of poetry in its purest form.

And then there's the music. The recordings found in these pages give a sense of the kinds of music he typically listened to while writing and the composers he most admired. You may notice two different recordings of John Cage's *Music of Changes*. In *John Ashbery in Conversation with Mark Ford*, Ashbery speaks about a period of writer's block starting in 1950 and describes going with Frank O'Hara to hear a concert of Cage's works, two years later, during which he "suddenly saw a potential for writing in a new way."[2] Further recordings of this Cage piece appear in Ashbery's full collection of some two thousand records, CDs, and cassette tapes. You'll also see various recordings by the likes of Gavin Bryars, Elliott Carter, Morton Feldman, Stefan Wolpe, Giacinto Scelsi, Alfred Schnittke, and other contemporary composers, along with more obscure classical repertoire and recordings of "early" music, with an emphasis on French Baroque repertoire.

I've also included a few recordings that relate to Ashbery in more personal ways. For example, the Leon Botstein recording features an obscure Ernest Chausson opera made known to Botstein by Ashbery when he taught at Bard College, where Botstein serves as both president and orchestra conductor. There are song settings of Rimbaud, whose poetry Ashbery translated. The recording of Elliott Carter's vocal works includes a performance of "Syringa," his Pulitzer Prize–winning setting of Ashbery's poem by the same title. Ashbery was a longtime Proustian; you'll find a recording of compositions by Proust's lover, Reynaldo Hahn. Popular music—such

as the recording by Pink Martini in the final playlist—also appears occasionally in the complete collection.

Many of the contemporary classical works Ashbery listened to feature complex textures, disparate sounds, and disjunct phrases. Rather than focus on traditional melodic development, many works emphasize the juxtaposition of aural objects coexisting in the same musical space. Much of Ashbery's poetry plays with both arcane and popular quotes and references, surprising juxtapositions, collaged elements, and sudden turns, such that a reader might construct multiple narratives or pathways of meaning. Much of the music he listened to might be enjoyed as aural landscapes, and we might enjoy much of his poetry similarly. Ashbery rarely offers linear stories or focuses on evocative descriptions of a single scene or object. We can read and think through his poetry in a multitude of ways, drawing different conclusions with each reading. Part of the gift of Ashbery's poetry is that it requires us—as active readers—to complete each poem.

The title of this volume, *Something Close to Music*, borrows a line from "Life as a Book That Has Been Put Down," a poem included here. As you explore this ekphrastic book project, I invite you to discover how for Ashbery the three "sisters," as Mónica de la Torre describes, in her introduction, music, poetry, and art writing, might illuminate and inform one another.

1 John Ashbery, "On Frank Faulkner," this volume, p. 56.
2 John Ashbery and Mark Ford, *John Ashbery in Conversation with Mark Ford* (London: Between the Lines, 2003), p. 35.

Three Sisters

Mónica de la Torre

Picture the sister arts Poetry and Painting in the oft-told story about ekphrasis. As you most likely know, the story goes that the former was given to talking, while the latter was mute. They were in a close relationship that was sometimes symbiotic, sometimes adversarial, and all too often love-hate. In the beginning, Poetry would tell stories that were epic, biblical, historic, while her sister would make stories materialize before an audience with an astonishing immediacy, presenting each and every one of their visualizable elements, even those that Poetry deemed too trivial to relate, for to relate them all would take an inordinate amount of time. Although Painting could transform words—even thousands of words—into pictures with borrowed content, she made no pictures of her own. She was no dummy, however, and eventually realized not only that she could paint whatever she wanted but that she had been doing so all along when it came to representing what couldn't be put into words. The tables would turn now and again, and when Poetry was tongue-tied, she would take inspiration from Painting instead, voicing the stories in her sister's works and sometimes even speaking as if from inside them, like a ventriloquist. When she did this, she was called "ekphrastic," although in truth she was often throwing her voice a bit, albeit surreptitiously.

Poetry loved the sound of her own voice and was prone to droning on. Her friends recommended that, if she wished to remain relevant in modern times, she stop wasting words and follow her sister's example by

using only those that supported the display of images in the poem. She'd also have to minimize contact with her other sister, Music, with whom she'd once been close, for Music spoke in a language too vague or abstract to pin down and was a bad influence. Her friends would riff off Horace's dictum *ut pictura poesis*: as is painting, so is poetry. Words were too precious to waste; she ought to economize! Poetry tried to comply, but in due course both she and Painting began wondering why they had to keep minding what the other one was doing. Why couldn't each just go about her business? It was time to set out on their own paths. That they did so, and merrily, did not mean that they would have to stop frequenting each other, even after art critics began courting Painting rather aggressively, advocating for her independence from the other arts under the banner of medium specificity. Whenever the sister arts got chummy with each other again, their respective friends warned that their identities would get all tangled up, leading to the much-dreaded confusion of the arts. But the sisters knew that family is family after all—each member's identity resulting from the projections intrinsic to family dynamics—and deep inside they relished their interdependence. Besides, they were feeling outshined by newcomers to the arts and old prescriptions were getting musty. The times had changed; modernism was old hat. Poetry started wondering why she couldn't visit with her sister Music more often. So passé were her old friends, they hadn't even noticed that Music had changed quite a bit herself.

*

Enter John Ashbery's "And *Ut Pictura Poesis* Is Her Name,"
an ars poetica of sorts, the final nail in the coffin of the
alleged duality between Poetry and Painting and a cel-
ebration of role-play and reversals. Is Poetry a speak-
ing version of her sister, or is Painting the silent poetry?
Emphatically both, and more, for here and elsewhere in
Ashbery's works Poetry is also on the continuum with
Music, striving as much to attain a certain musical effect
as to communicate something that, not unlike a tune,
evanesces as it is being emitted. While the poem, from
Houseboat Days (1977), is not included in the present vol-
ume, its funhouse-mirror quality is very much present in
the materials collected here. An excerpt reads:

> So much for self-analysis. Now,
> About what to put in your poem-painting:
> Flowers are always nice, particularly delphinium.
> Names of boys you once knew and their sleds,
> Skyrockets are good—do they still exist?
> There are a lot of other things of the same quality
> As those I've mentioned. Now one must
> Find a few important words, and a lot of low-keyed,
> Dull-sounding ones....
>
> We were a seesaw. Something
> Ought to be written about how this affects
> You when you write poetry:

17

The extreme austerity of an almost empty mind
Colliding with the lush, Rousseau-like foliage of its
 desire to communicate
Something between breaths, if only for the sake
Of others and their desire to understand you and
 desert you
For other centers of communication, so that
 understanding
May begin, and in doing so be undone.[1]

Blame it on cybernetics: in the new era, the belletrist sisters' tendencies, identified by Ezra Pound as logo-poeia, melopoeia, and phanopoeia, all even out. Their entanglement here also seems to stem from Ashbery's kaleidoscopic perspective, shifting from that of close listener to aspiring artist, poet, art writer, and collagist as multifariously as the objects of his contemplation. And let's not forget his sustained practice as a translator from the French, translation perhaps being the mode most akin to the manner in which his ideas about one medium flow into another as imperceptibly as liquids in communicating vessels.

That ekphrasis—and the collisions between works of art in different media—was a persistent concern of Ashbery's makes sense considering that his first encounter with painting sparked his desire to take up surrealism, itself a crossbreed between literature and art. In the first essay in this collection, he recalls chancing upon coverage of The Museum of Modern Art's 1936 exhibition *Fan-

tastic Art, Dada, Surrealism in the pages of *LIFE* magazine, at the tender age of nine.[2] Seeing the spreads packed with reproductions of surrealist classics, such as de Chirico's *The Sailors' Barracks* (1914), Magritte's *The False Mirror* (1928), and Dalí's *The Persistence of Memory* (1931), prompted him to take art lessons in grade school—the works' ghostly colonnades, impossible landscapes, and melting clocks luring him into the dreamworld. "And in some room someone examines his youth, / Finds it dry and hollow, porous to the touch" read lines from "Vetiver," the poem paired with Ashbery's opening essay in this volume, offering a vivid take on what it's like to attempt to conjure a childhood self.[3]

Ashbery continued taking classes until he was fifteen and only stopped painting when he enrolled at Harvard in 1945. Surrealism's tenets arguing for the supremacy of art over reason, the endless bounties to be found in the oneiric realm, and absolute creative freedom would go on to inform his approach to artmaking and poetry throughout his adult life, despite his objections to some of the literary notions at the movement's core. When queried for *The Paris Review*, he said, "I don't believe in automatic writing the way the surrealists were supposed to have practiced it, simply because it is not a reflection of the whole mind, which is partly logical and reasonable, and that part should have its say too."[4] In Ashbery's universe, rationalism's takedown unfolds amid quasi-logical thinking so convincingly that the poems arrive at propositions that seem surprisingly reasonable.

Ashbery ultimately found making poetry easier than continuing to paint, but the possibilities he envisioned for writing emerged as much from the drawing board as from his early scribbles on the page. He admits as much to Jarrett Earnest in *What It Means to Write About Art: Interviews with Art Critics*: "Every day I'd do a lot of drawings, usually of women in beautiful gowns—maybe I thought I'd be a dress designer, which I would have been quite good at.... Aside from a few childhood ventures, I didn't start writing poetry seriously until the early 1940s. When I started writing poetry, I carried it over into that."[5] A reverse flow also occurred, his poetic imagination suffusing the art reviews he began to write for *ARTnews* in 1957. Pragmatism prompted his foray into the genre. He goes on to explain in the same interview, "I felt that I was never really qualified to be an art critic. The only reason I did it is because I needed to earn some money.... It was obviously pretty easy to write about abstract expressionist painting, since it was brand new and nobody knew anything about it, so what you had to say was as valid as what anyone else might. Also, it's not unlike the poetic process in its being a record of its own coming into being."[6]

Notice how his stance on poetics slips into his recounting of the early days of ab-ex, indicating that, as separate as he sought to keep his identities, the two were always intertwined. When he began writing about art, Ashbery was not only already a published poet; he was also steeped in the downtown art world. His first book,

Some Trees (1956), had won the prestigious Yale Younger Poets Prize, judged by W. H. Auden no less, but this distinction failed to prevent him from having to write meagerly paid art reviews to eke out a living. Many of the poems in *Some Trees* had originally appeared in Ashbery's first chapbook, *Turandot and Other Poems*, accompanied by drawings from Jane Freilicher and published as part of Tibor de Nagy Gallery's famed *Painters and Poets* series in 1953. He'd met Freilicher and Larry Rivers through the poet Kenneth Koch, whom he had befriended at Harvard, upon moving to New York in 1949. That same year, he met Frank O'Hara, who had also written for *ARTnews*. Alongside Freilicher and Rivers, Ashbery had starred in Rudy Burckhardt's *Mounting Tension* (1950), playing a straight bat-swinging jock whom Freilicher drags to The Museum of Modern Art. Although he doesn't break character in the film, his feigned disregard for art is charming but not terribly convincing; he seems to be enjoying the making of an art film as much as everybody else. Of Freilicher's paintings, he would make beautifully eloquent statements almost half a century later, capturing perhaps the spirit of his own creative project as well. In his essay for her show at the Fischbach Gallery in 1995, included here, he admits to finding the presence of light in her canvases to be the result of her "determination to impose her own revisionist light on what was after all a mere suggestion in nature" and goes on to praise her "radical overhauling of what was seen."[7]

Art writing might have been Ashbery's "accidental

sideline," but his engagement with the genre was a life-long activity. After writing for *ARTnews*, he returned to Paris in 1958 and became the art critic for the European edition of the *New York Herald Tribune* from 1960 to 1965. Back in New York in '65, he went on to serve as executive editor of *ARTnews* and as an art writer for *New York* magazine and, finally, *Newsweek*. Many of the articles he wrote for these and other publications are collected in *Reported Sightings: Art Chronicles 1957–1987* (1989). The present volume picks up where *Reported Sightings* left off and includes inspired selections by Jeffrey Lependorf, pairing essays written after Ashbery's thirty-year official career as art critic had ended with poems from his books published in the same years. Once he was no longer working for art magazines, Ashbery mostly wrote for publications devoted to his friends and those in the New York School constellation with whom he had been closest from the beginning: among them Freilicher, Rivers, and Burckhardt.

The writing you are about to read is at once exuberant, heartfelt, and vivid, breezy yet thick with accumulated experience. Overall, Ashbery's art criticism rarely feels constrained by the standards expected of specialized critics and art historians—poets and artists are the only authorities he quotes. Yet here it feels even more freewheeling. The essays often read like palimpsests in which layers of reflections drawn from different time periods are overlaid on top of one another. They range from anecdotal vignettes to precise yet nonetheless ec-

centric observations, often personifying the art under discussion; from character studies of the artists to records of Ashbery's experience of experiencing both the artworks and the artists who made them. After all, he did claim that his poems sought to capture not experience but "the experience of experience,"[8] clearly a gregarious one at that.

Included, too, is an excerpt from Ashbery's explicitly ekphrastic book-length poem, *Girls on the Run* (1999), written after the outsider artist Henry Darger. The passage excerpted in this volume finds a brilliant counterpoint in Ashbery's introduction to the book *Trevor Winkfield's Pageant* (1997). Unlike his most celebrated ekphrastic poem, *Self-Portrait in a Convex Mirror* (1975), a dialogue with and digressive reflection on the eponymous Renaissance painting by Parmigianino, *Girls on the Run* is a riff on and departure from Darger's illustrated novel featuring the Vivians, the fictive gaggle of audacious prepubescent girls dreamed up by Darger with imagery from comic strips, coloring books, and ephemera. A line from the excerpt reads, "An illustration changes us."[9] The poet slips into the artist's mind and animates his fiction by making its loquacious characters not simply speak and tell stories but also urge and answer others, volunteer and suggest opinions, gurgle and grumble their thoughts, and insist on the most outlandish things, for it would be dull to have them simply *say* things. That is, here ekphrasis consists of recruiting poetry to make art come to life in the liveliest of all

possible manners, through speech. "For a long time a very prosaic language, a language of ordinary speech, has been in my poetry. It seems to me that we are most ourselves when we are talking, and we talk in a very irregular and antiliterary way," Ashbery explains in his interview with *The Paris Review*.[10] In shifting from polyphony to cacophony and back, *Girls on the Run* puts this very stance to the test.

Ashbery's foreword to the publication for Joan Mitchell's exhibition at Robert Miller Gallery in 1992 switches modes so seamlessly we forget whether we're reading a tribute, a fragment of a memoir, or a catalogue essay. In this way it is indicative of the sui generis nature of the essays in this collection. Recalling his first time seeing Mitchell's art, in 1952, Ashbery is only able to remember "a sensation of gyrating fan-blade shapes, chilly colors, and an energy that seemed to have other things in mind than the desire to please."[11] This description seems equally applicable to the artist herself, whom he favorably characterizes as having "a knack for putting you ill at ease immediately." When it comes to her paintings, he recommends going with the flow, which, like Mitchell, is "a force that is tidal and inescapable once one accepts the terms of engagement." At the end of the essay, Ashbery takes on the role of interpreter, offering that perhaps Mitchell is saying, through her late painting *Ici* (1992), "Here! … is where life is, is what it is." The realization is one that "can transform itself from truism into palpitating reality" in the right circumstances. The

poem thoughtfully chosen to accompany the essay is "The Improvement," one that both is mournful and jolts the reader into the present in which the encounter with words unfolds: "We never live long enough in our lives / to know what today is like. / Shards, smiling beaches, / abandon us somehow even as we converse with them. / And the leopard is transparent, like iced tea."[12] A few lines down, the poem might as well be speaking to the furious bursts of color in Mitchell's canvases: "I want the openness / of the dream turned inside out, exploded / into pieces of meaning by its own unasked questions."

This collection is replete with such poignant dialogues between Ashbery's poems and the art and artists inspiring his essays. Part of the pleasure of reading these texts is discovering, through lines and connections between the pairings, the way they rhyme and shed light on one another. It's hard not to realize, for instance, how fitting it is to have the poem "Moderately" appear with an appreciation of Joe Brainard, whom Ashbery describes tenderly as "one of the nicest artists I have ever known" who perhaps "in an ultimate gesture of niceness ... didn't want us to have the bother of bothering with him."[13] "Moderately" points, too, to Brainard's vulnerability as a gay man growing up in the repressive fifties and to his classic catalogue of fragmented memories *I Remember* (1975) with lines such as, "And I remember no longer at the age of sixteen, / and at the age of seventeen great rollers / eating into night."[14] The poem "Mutt and Jeff," after the comic strip's "mismatched tinhorns," as the era's

vernacular would have it, appears alongside a piece on a comically rendered Larry Rivers, "a pain in the ass" according to Ashbery, yet an essential one given that "life would have been sanitized and dull without the knowledge that Larry was constantly running around in the background, sometimes emerging into the foreground."[15] Ashbery's affinities come into sharp relief throughout the selections to such an extent that the collection at times reads as a refracted self-portrait as well.

One such affinity is, of course, New York, apropos of which he offers the delightfully improbable observation, in an essay on Val Lewton's noir film *The Seventh Victim* (1943), that "like Paris, [it] is always ready for its close-up. Somehow the city never fails to look good on the screen, where it quickens excitement the way the place itself does."[16] A similar optimism lies at the heart of Ashbery's praise of Rudy Burckhardt: "Few other photographers have seen as deeply into the way streets and people look, and been able to report back that the news is good: we're all in this thing together, and that is just as it should be."[17] Those were the days, for some, at least. But that's another matter. The city Ashbery loved has multiple entry points, like this collection. What's best, you can pick the one of your choosing or you can go through them all at once. Read it as an object lesson not so much on how to write poems and essays *about* art but on how to write *through* and *out* of art. Read it as a discontinuous record of Ashbery's loves, of the intensity of his fellow feeling toward the artists in his milieu and his gen-

uine amazement at the art being made by them. And read it, too, as a side entrance into Ashbery's poetics and as a record of the ecstatic entwinement of art, poetry, and music in his mind. For once, the writing Ashbery produced while listening to music—deliriously ranging from Christian Wolff's works to John Cage's indeterminacy to Brian Eno's soothing ambient music to Conlon Nancarrow's zany player-piano compositions—appears side by side, to the delight of the three sisters. You can feel them throughout the collection horsing around, aping one another, and egging one another on.

Original publication information for the texts that appear in this volume can be found on pages 171–176.

1 John Ashbery, *Collected Poems 1956–1987* (New York: Library of America, 2008), p. 519.
2 "Surrealism on Parade," *LIFE* (December 14, 1936), pp. 24–27.
3 John Ashbery, "Vetiver," this volume, p. 31.
4 John Ashbery, "The Art of Poetry No. 33," *The Paris Review*, no. 90 (Winter 1983), accessed online.
5 Jarrett Earnest, *What It Means to Write About Art: Interviews with Art Critics* (New York: David Zwirner Books, 2018), p. 29.
6 Earnest, *What It Means to Write About Art*, pp. 30, 31.
7 John Ashbery, "On Jane Freilicher (I)," this volume, p. 83.
8 Robert Kelly and Paris Leary, *A Controversy of Poets: An Anthology of Contemporary American Poetry* (Garden City, New York: Doubleday, 1965), Biographical note.
9 John Ashbery, "Girls on the Run," this volume, p. 109.
10 Ashbery, "The Art of Poetry."
11 John Ashbery, "On Joan Mitchell," this volume, p. 74. Subsequent quotes from this essay are found in this volume, pp. 75, 79.
12 John Ashbery, "The Improvement," this volume, p. 80.
13 John Ashbery, "On Joe Brainard," this volume, pp. 96, 98.
14 John Ashbery, "Moderately," this volume, p. 99.
15 John Ashbery, "On Larry Rivers (I)," this volume, pp. 70, 71.
16 John Ashbery, "On Val Lewton," this volume, p. 141.
17 John Ashbery, "On Rudy Burckhardt (II)," this volume, p. 150.

Something Close to Music

Late Art Writings and Poems by John Ashbery,
with Playlists

"As a child I always wanted ..."
1988

As a child I always wanted to be an artist and drew constantly—mostly figures of women. In 1936, when I was nine, *LIFE* did a spread on the *Fantastic Art, Dada, Surrealism* show at The Museum of Modern Art, and that made me want to be a surrealist. I even drew some drooping watches and suchlike. Since the rural grade school I attended had no art classes, I got permission to attend the weekly painting classes at the Memorial Art Gallery in nearby Rochester, N.Y., and did so for five years. I spent the last two years of high school at Deerfield Academy in Massachusetts and there studied informally in the workshop of the resident painter, Donald Greason, a talented and somewhat eccentric man with a strong anti-modernist bias—for him art stopped at Cézanne, as I recall, and even Cézanne he accepted somewhat grudgingly. He didn't exactly try to discourage my surrealistic bent, but told me I'd first have to learn to draw and paint from the model and then we'd see. So I applied myself to painting still lifes that were as faithful to the models as I could make them, and even attempted a self-portrait that had a small succès d'estime with my fellow students. Just before graduating in 1945 I attempted to broaden my style by painting a "cubist" still life, using the same objects—a copper pitcher, wax grapes, a ginger jar, and some draperies—that I had painted many times before.

That was to be the last picture I would paint for a number of years, though in college I tried my hand at collages (surrealist, bien entendu). Painting in a small dorm room was out of the question, and like William Carlos Williams, who painted in his youth, I had made the discovery that "it was easier to carry around a manuscript than a wet canvas." Besides which I had been writing poetry for several years and coming to the conclusion that it was what I wanted to do.

The still life in this show happened by chance. In the spring of 1955 I spent a weekend at the home of my friends Fairfield and Anne Porter in Southampton. I expressed curiosity about the Maroger medium that Fairfield used for painting and which he cooked up in batches on an old stove in his studio. He offered to let me try it and set up a canvas for me in his living room, where I painted the objects on the mantelpiece. I never painted after that (possibly because I had so many friends who were more talented painters than I could ever hope to be), though a couple of years later I began reviewing for *ARTnews*, and have continued to write about art since then. So art has been a kind of accidental sideline for me, often in my thoughts, and close, though not all that close, to my main interest of writing.

Vetiver

Ages passed slowly, like a load of hay,
As the flowers recited their lines
And pike stirred at the bottom of the pond.
The pen was cool to the touch.
The staircase swept upward
Through fragmented garlands, keeping the melancholy
Already distilled in letters of the alphabet.

It would be time for winter now, its spun-sugar
Palaces and also lines of care
At the mouth, pink smudges on the forehead and cheeks,
The color once known as "ashes of roses."
How many snakes and lizards shed their skins
For time to be passing on like this,
Sinking deeper in the sand as it wound toward
The conclusion. It had all been working so well and now,
Well, it just kind of came apart in the hand
As a change is voiced, sharp
As a fishhook in the throat, and decorative tears flowed
Past us into a basin called infinity.

There was no charge for anything, the gates
Had been left open intentionally.
Don't follow, you can have whatever it is.
And in some room someone examines his youth,
Finds it dry and hollow, porous to the touch.
O keep me with you, unless the outdoors

Embraces both of us, unites us, unless
The birdcatchers put away their twigs,
The fishermen haul in their sleek empty nets
And others become part of the immense crowd
Around this bonfire, a situation
That has come to mean us to us, and the crying
In the leaves is saved, the last silver drops.

On Rodrigo Moynihan
1988

Just today I received in the mail an exhibition calendar from the Yale Center for British Art, announcing among other things a retrospective of Victor Pasmore's work (Pasmore of course was associated with Rodrigo Moynihan in the Euston Road School, London, in the early thirties). Since I had been thinking about the "grayness" of much English painting and particularly of the wondrously luminous, succulent grays of Moynihan's most recent realist period, I was startled by a statement about Pasmore that seemed to typify the reductive wrongheadedness that gets into discussions about light in painting: "Since 1966 Pasmore has owned a house in Malta, and the Mediterranean light and bright color have clearly influenced his recent work. His explorations of light, space, and color can now be seen as part of a fundamental lifelong interest."

If Pasmore had never gone to Malta, it is implied, we should never have been able to see those explorations of light, space, and color as part of a fundamental lifelong interest. It is common to assume that painters in northern countries have no real idea of what sunlight is (though the sun always seems to shine much more brightly in England than the natives give it credit for). Take a painter out of Glasgow or Oslo or Montreal and plunk him down on the Riviera and chromatic hell breaks out in his canvases, or so the assumption goes.

Of course there are exceptions. Some pre-Raphaelite landscapes are notable for effects of crystalline atmosphere in which color becomes hard and jewel-like, and does not look as though it were brushed over gray. On the other hand, early cubism is always gray, even when the subjects are ostensibly "Mediterranean," as with Braque's and Picasso's landscapes of Horta de Sant Joan and l'Estaque. Indeed, much of the supposed *luxe, calme et volupté* of Matisse's Nice period is surprisingly low-keyed in color and at times downright bituminous. The reason may have been an urge to express light more faithfully: an overabundance of sun can produce an effect of monochrome. In many of these pictures light seems to be directing: "I am light. Color me gray."

In the case of such English painters as Sickert, Coldstream, Freud, Bacon, Auerbach, and Moynihan, it never occurs to anyone that the perceived grayness in their work is the result of an expressive purpose and not of ignorance of everything save bleak skies and smokestacks. The proof that it is a question of temperament is borne out by the fact that when they move about, British painters often carry their skies with them. Mackintosh's Riviera watercolors are pale and discreet, and the climate of Dieppe in Sickert's work looks no different from that of Camden Town (perhaps it isn't). Many of Moynihan's still lifes and portraits of the last decade and half were done in Provence, and their silvery tones seem as much an attempt to deal with and interpret a surplus of sunlight as does the hard-edged abstraction of the previous

decade, where red and green are confined by black or look as if they were laid down over it. (Similarly, the pictures he has done recently in London are riper and moister in color within the context of their dove-gray London studio light.) Clearly, light and color are not the same thing in painting: the former is often best expressed by a double negative, and violent chromatic juxtapositions frequently do not translate it at all.

I first met Rodrigo Moynihan and his wife Anne Dunn on an extremely gray day in January 1961, in a drab section of Paris near the Porte Brancion where in fact the sun seemed seldom if ever to shine (I know because I lived not far away myself). We had a mutual friend in Jean Hélion, a marvelous and still-underestimated painter whose work fascinated me ever since I first saw a show of it in New York in 1950. Hélion called one day and suggested I might like to look at the painting of Rodrigo Moynihan, and though his recommendation would have been enough, what really attracted me was the name: what full-throated, nicely rounded names the English so effortlessly manage to have! I didn't know at the time that Rodrigo was half Spanish, and had been born in the Canary Islands. The Moynihans lived in a working-class district with a few pretensions to *la vie de bohème*. Close by was the hive-shaped studio building known as La Ruche, and across the railroad tracks in the *quatorzième* were other more or less dilapidated buildings where artists lived, including Giacometti. But the flavor was mostly proletarian. In this anonymous district the Moynihan

house almost stood out in its anonymity: hidden in a courtyard behind a hostel for Norwegian students, it consisted of a small kitchen and dining room on the ground floor, a bed-sitting room above, and a fairly capacious two-story studio at the back.

Here I got to see my first Moynihan paintings: harsh and bitter in mood, and execution, with stabs and spatters of dark gray, blue and black, but without the juicy accumulations of pigment courted by Pollock or de Kooning. It was a time of transition for painting, though one didn't know it (does one ever?). In New York the abstract expressionist monolith had begun to show cracks caused by the vibrations of pop art and other irreverent new isms; in England the serene abstraction of Ben Nicholson and his contemporaries was being similarly challenged, and Paris had its new realists, a highly didactic spin-off of pop. None of this mattered much to Moynihan, who, like Hélion, had for many years been following a path among obstacles he saw, not those that others decided were there. In London a few months later I saw examples of his earlier work and realized just how original, in the context of his career as a whole, were the abstractions I had seen in Paris. Among these was an "infamous" objective abstraction that his friend Geoffrey Tibble had dubbed "Explosion in a Jam Factory" (a variant, no doubt, of "Explosion in a Shingle Factory," which is what American critic of the Armory show called Duchamp's *Nude Descending a Staircase*)—as I recall it was hanging on the back porch of a friend's house in Little Venice. I also saw

some of the realist paintings that followed objective abstraction, notably the splendid group portrait of *The Teaching Staff of the Painting School, Royal College of Art*, whose mood of claustrophobic camaraderie always reminds me of Hals's *Regents of St Elizabeth Hospital*.

The dusty, peachy scumbles of the early abstractions were both provocative and soothing (surely the jam in that factory must have been rhubarb and quince?); but so was the just-right astringency of the work that followed. But what appealed to me most was Moynihan's habit of going about his business without asking for permission or directions, of *just doing it*. The curious sensuality of the objective abstractions and their lack of resemblance to anything else being done at the time stemmed from the conviction they conveyed that it was the time for doing this thing and no other. Similarly, the fact that Moynihan could reverse himself so completely in the seemingly academic portraits of the forties and still retain the integrity that blazed in his work from the beginning was what counted: in both cases, not only the results but the movement they charted. And, as I knew, he had already wiped the slate clean again before smearing it with the angry abstractions—more subjective than objective this time—of the early sixties. One could tell that the work would change again—and again. Clearly, here was an artist who forced one to follow him, rather than keeping one chatting at a fixed point in space and time. Everyone who is trying to create something needs to know someone like that.

For Moynihan, progress until recently has meant fluctuating between two widely divergent poles—though of course there will always be resemblances since the same mind has been at work. In the last fifteen years the poles have approached one another in the series of unarranged studio lifes—which continues. They are preceded by the hard-edged paintings of the late sixties (inspired in part by landscapes near the camp in New Brunswick where Anne and Rodrigo spent some of every summer), in which bands of strident color traversed the canvas seemingly at high speed. These gradually metamorphosed into the shelf or deal table whose horizontality is exaggerated by a point of view just above their surface, so that their depth is barely noticeable, and their further edge becomes a supplementary horizontal indicator, along with T squares, stretchers, and other tools of the studio. Most of the objects portrayed are raw materials of the painter's trade: plastic jugs of solvent, bars of soap, cylindrical bales of cotton wool. One of the implications is that the painting itself is to be nothing but the product of these still unused materials, that this is all there is, that there is no "deeper meaning." And their shapes suggest those in the abstract paintings: self-contained, unrevealing of themselves except for the fact of their coinciding in a certain place at a certain time.

So, after a long period of flux, a kind of truce has been reached: the yearning toward realistic depiction and the equally strong urge toward abstraction have come together and joined forces in the neutral territory of the

studio—neutral, that is, in every way except color, since the mating of opposing forces has somehow released reservoirs of color unlike any in his previous work, though its ancestry is not hard to trace, even as far back as the resonant paleness of the objective abstractions. But these are now newly marshalled, aware of themselves. The creamy edge of the raw wood shelf in the 1982 *Still Life, Cotton Wool and Soap*, for instance, speaks with a crisp and newfound authority, ignoring the fact that there was never anywhere quite such a hue as this—rich, calm, self-effacing, and dominant all at once.

Knowing Moynihan, the truce may well again turn out to be temporary. But for the moment, at least, the resolution he has found seems a climax to a curious yet inevitable progression. As he once wrote in a brief essay called "Notes on Impressionism and Abstract Painting": "Logic cannot pretend to isolate a 'classical' art, make it possible under any conditions, give it canons and a determinate goal. The sterility of an art begins when it ceases to deny itself, when the artist acquires superstitions and no longer has the will to reject."

Life as a Book That Has Been Put Down

We have erased each letter
And the statement still remains vaguely,
Like an inscription over the door of a bank
With hard-to-figure-out Roman numerals
That say perhaps too much, in their way.

Weren't we being surrealists? And why
Did strangers at the bar analyze your hair
And fingernails, as though the body
Wouldn't seek and find that most comfortable position,
And your head, that strange thing,
Become more problematic each time the door was shut?

We have talked to each other,
Taken each thing only just so far,
But in the right order, so it is music,
Or something close to music, telling from afar.
We have only some knowledge,
And more than the required ambition
To shape it into a fruit made of cloud
That will protect us until it goes away.

But the juice thereof is bitter,
We have not such in our gardens,
And you should go up into knowledge
With this careless sarcasm and be told there
For once, it is not here.

Only the smoke stays,
And silence, and old age
That we have come to construe as a landscape
Somehow, and the peace that breaks all records,
And singing in the land, delight
That will be and does not know us.

On Yves Tanguy
1989

How surreal is surrealist painting? The question has
been argued at least since 1925, when Pierre Naville wrote
in the review *La Révolution surréaliste*: "Everyone knows
now that there is no *surrealist painting*. Neither pencil
marks recording chance gestures, nor images represent-
ing dream figures, nor imaginary fantasies can be so
qualified." He went on to clarify this point somewhat:
"How is it that what we call literature is nurtured almost
exclusively by love, and that words turn love so easily to
account, while the plastic arts are cut off from it, or that
we only glimpse it there, veiled and ambiguous? There
is really no literary equivalent of the *nude*."[1]

Perhaps even literature had to cheat a little in order
to be able to call itself surrealist. Automatic writing was
the ideal, and it was occasionally practiced by Breton and
others during the early days of the movement, but the
results are usually so unsatisfactory as literature that
something obviously had to be done. Even the writing
labeled "automatic" has obviously been shaped and
smoothed after the fact of its execution, while the finest
poetry of Breton, Éluard, and Aragon shares the ideals
of order and clarity that have characterized French liter-
ature since Racine and Boileau: only the subject matter
is different. How much more difficult then for a painter
to transcribe the spontaneous madness of the surrealist
vision with the laborious means at his disposal. Thus,

from the beginning most surrealist painters settled for illustrating Naville's "images representing dream figures" with techniques not very different from those of a van Eyck or a Vermeer. Not until the later works of Jackson Pollock and action painting would the act of painting itself become surrealist, and by that time painting was abstract, having abandoned dream figures.

Although the surrealist painters sometimes used random procedures such as Ernst's frottage, Masson's sand painting, and Wolfgang Paalen's *fumage*—in which smoke from a lit candle held close to the canvas was used to suggest forms—the results have the finished look of these artists' traditionally made pictures and those by Dalí, Magritte, and Delvaux. Hence, a staleness or weariness in so much of this work: the energy of the image has been siphoned off into the task of representing it.

One could argue that a handful of artists, in their different ways, successfully met the challenge of surrealism's call for the *liberté totale*: Arp, despite his abstract language; Klee and de Chirico, although they remained on the fringes of the movement; Miró, whose customary badinage can seem alien to its spirit; and especially Tanguy. As his style evolved from its rather crude and naive beginnings in the 1920s through the amazing illusionism of his later years, it came to seem a mechanism as skilled and impersonal as a camera lens, ideal for documenting the imaginary animal, vegetal, and mineral phenomena that inhibit his paintings: beings of a type never encountered before yet palpably real, living if not breathing.

Once articulated, his mature style changed very little; instead, development takes the form of a steadily increasing tension. Forms can pullulate endlessly, amoeba-like, in late paintings such as the 1954 *From Green to White*, although they can just as easily turn monolithic, as in *My Life, White and Black*, of a decade before. At most, there are shifts of perspective in some of the pictures of his last phase: one's viewpoint may be situated slightly below the activity on the canvas, instead of above it; objects can crowd the foreground instead of receding endlessly toward the horizon. Color takes on a greater feeling of saturation or sharpness. Tanguy noted in the 1940s: "Here in the United States the only change I can distinguish in my work is possibly in my palette.... Perhaps it is due to the light. I also have a feeling of greater space here, more 'room.' But that was why I came here."[2]

Although Dalí and Magritte were equally skilled technicians, and Dalí perhaps even more so, what they chose to record was the real world seen through surrealism's distorting lens. The concrete abstractions that are constantly erupting onto Tanguy's canvases are closer to the surrealist ideal of "all that has never been, which alone interests us," in Éluard's phrase:[3] paradoxically spontaneous despite the hours of painstaking labor that went into their execution. Thus, at a time when people no longer have problems construing as art Naville's "pencil marks recording chance gestures," when the results seem to warrant it, Tanguy's painting speaks directly to us. The trappings of retro-chic that dilute the message

of his gifted contemporaries are simply absent; there is no residue of either craft or literary content. His work is surrealism in its purest visual form, and therefore ranks with the most powerful artifacts our century has produced.

1 Pierre Naville, "Beaux-Arts," *La Révolution surréaliste*, no. 3 (April 15, 1925), p. 77.
2 Yves Tanguy, *Arts Digest* 28, no. 14 (January 15, 1954), p. 33.
3 Paul Éluard, "Raymond Roussel: L'Étoile au front," *La Révolution surréaliste*, no. 4 (July 15, 1925), p. 32.

Playlist I
1988–1990

1988

Ferruccio Busoni—*Chaconne, Mephisto Waltz, Fantasia Contrappuntistica*—Christopher O'Riley (Centaur)

John Cage—*Music of Changes*—Herbert Henck (WERGO)

Elliott Carter—*The Music for String Quartet Vol. 1: String Quartets 1 + 4; The Music for String Quartet Vol. 2: String Quartets 2 + 3, Elegy*—The Arditti String Quartet (Etcetera)

Conlon Nancarrow—*Studies for Player Piano, Vol. V* (WERGO)

Giacinto Scelsi—*Canti del Capricorno*—Michiko Hirayama (WERGO)

Stefan Wolpe—*Piano Music*—Geoffrey Douglas Madge (cpo)

1989

John Adams—*Fearful Symmetries, The Wound-Dresser*—Orchestra of St. Luke's, John Adams, Sanford Sylvan (Elektra Nonesuch)

Ferruccio Busoni—*Doktor Faust*—Dietrich Fischer-Dieskau, Karl Christian Kohn, William Cochran, Ferdinand Leitner (Deutsche Grammophon)

François Couperin—*Second livre de clavecin*—Kenneth Gilbert (Harmonia Mundi)

Sofia Gubaidulina—*Offertorium*—Gidon Kremer, Boston Symphony Orchestra, Charles Dutoit (Deutsche Grammophon)

Witold Lutosławski—*Volume 5: Symphony No. 3, Chain 1 for Chamber Orchestra, Chain 2 for Violin and Orchestra, Ad Libitum, A Battuta*—The Polish Radio National Symphony Orchestra in Katowice, Antoni Wit, Junge Deutsche Philharmonie, Heinz Holliger, Kazimierz Kord (Polskie Nagrania Muza)

Bruno Maderna—*Concerto per violino, Concerto no. 2 per oboe, Quadrivium*—Theo Olof, Lothar Faber (Stradivarius)

1990

György Ligeti, Franco Donatoni—*Études pour piano, 1er Livre*; *Trio pour violon, cor et piano, Tema, Cadeau*—Pierre-Laurent Aimard, Ensemble intercontemporain, Pierre Boulez (Erato)

Witold Lutosławski, Henryk Górecki, Sergei Prokofiev—*Dance Preludes, Lerchenmusik, Overture on Hebrew Themes*—Camerata Vistula (Olympia)

Bruno Maderna—*Quadrivium, Aura, Biogramma*—Giuseppe Sinopoli (Deutsche Grammophon)

Andrzej Panufnik—*Sinfonia Sacra, Arbor Cosmica*—Royal Concertgebouw Orchestra, New York Chamber Symphony (Elektra Nonesuch)

Alfred Schnittke—*Symphony No. 1*—The USSR Ministry of Culture Orchestra, Gennady Rozhdestvensky (Melodiya)

Iannis Xenakis—*Oresteïa*—Festival Musica Strasbourg (Salabert)

Flow Chart: Part II
(*Excerpt*)

No one has to re-invent himself at each new encounter
 with something different or slightly new.
Nowhere does it say that results will issue from a recent
 overhauling.
We don't know what hamlets lie in our path, or how much
 grumbling will occur
when we knock over something metallic and it makes
 a loud clang, audible on the stairs below,
or whether there will be a comic ending to this. We can
 see into the future
as into a dimple, and nothing says not to proceed, to go
 on planning,
though we know this cannot be taken as an authorization,
 even less as approval of the morass
of projects like half-assembled watches, that surrounds
 us. No but there is a logic
to be used in such situations, and only then: a curl of
 smoke or fuzziness in distant trees
that tempts one down the slope, and sure enough, there
 is a village, festive preparations,
a votive smile on the face of each inhabitant that lets you
 pass through
unquestioned. And we thought we were lucky back there
 in the silence! Here, civilization takes over,
at its highest, a new trope that dazzles without intimidating,
 like a scroll, is ready for us

and however many more of us it takes to change moods,
 build the palace of reason our
inconsequence has promised for so long now, out of
 trued granite blocks fired with chips of mica,
and so get over feeling oppressed, so as to be able to
 construct the small song, our prayer
at the center of whatever void we may be living in: a
 romantic, nocturnal place
that must sooner or later go away. At that point we'll have
 lived, and the having done so would
be a passport to a permanent, adjacent future, the adult
 equivalent of innocence
in a child, or lost sweetness in a remembered fruit:
 something to tell time by.
By then we'll know, as surely as if parents catechized us,
 the empty drum that offers itself
to any yearning, the daily quotient, the resolution, but
 also bare facts scattered on a plain
of fires, data that cannot be checked, dictates to live by,
 unlikely as it now seems.
And scattered over these, the dust of heavens that
 incorporates some of the good things and others
you'll most likely want to avoid, if you can, otherwise
 torpor builds up in plumes
on the horizon, and when you go
to convert your notes into hard currency, something will
 be lacking though the columns
of figures add up correctly, and there seems to be no
 mystery

to it, beyond a pleasant, slightly numbed sense of
 wonderment which was in any case
on your original want list. Although we mattered as
 children, as adults we're somehow counterfeit
and not briefed as to what happened in the intervals to
 which this longing led us,
which turns out to be not so tragic after all, but merely
 baroque, almost functional.
Yet there can be no safety in numbers: each of us wants
 and wants to be
in the same way, so that in the end none of us matters,
 and in different ways
we cannot understand, as though each spoke a different
 language with enough cognates
to make us believe in deafness—*their* deafness—as well
 as in our own reluctance
to dramatize, leaving our speech just sitting there,
 unrinsed, untasted, not knowing us,
or caring to. Each day the ball is in our court, and worse,
this is probably unromantic and proper procedure, *fons
 et origo, nemine dissentiente.*

Hours, years later, we were together.
The moon unbarred its hold, the thickness of brambles
 was compacted
just in time to prevent the closing of the door as if by
 magic—"It always
happens that way, and then no one can find it. Pretty
 please,

not in the terrarium, but outdoors, that vague nest,
and others will conspire to push the lawnmower, make
 coffee, as long as these
and ours are spared and stand along the walk in rows.
 We might never
get out alive otherwise. Besides, there's all that to see,
all that and more, you see, not including
the glint in someone's eye when you tell them that,
 and afterwards, well, it's back to
your tunnel or whatever you care to call where it is you
 stay
in the afternoons, then morning, if all goes well. And if
 we two inhabit
a daffy teacup, are adept at crowd-pleasing, then what
 about the rest,
star-gazers in their midst, who make up the electorate?
 Say it was long ago,
say nothing further need be said, that even a memory
 will traipse
across the crossed hairs and be shot down, only the
 comfort in it
will be, will not have been
for many years, and though these die
with a sheen on them there is not very much to mark
of that past, no stones to leave on the trail, which isn't
 the same
as having an alderman in your living room and cats
 wherever you look,
fond George."

Then it said it was supposed to come back
to an eyrie or some sort of enclosed space, it wasn't
 too clear
about that, but definitely would walk to meet us
whether we were here, or far. It would meet us. And so on.
 If living
was going to be like that, give me back my clothes, my
 crown
of gold, and just let me out before I have had a chance to
 put them on,
regal when partially naked, and you can bet the next one
 that comes along
will have his say, and then we are gay, and be under
 a mushroom
the livelong day, because no one wants to play
any more. The mouse ran up the clock, the clock struck
 one, and it all lurched
into motion again like an ancient conveyor belt an unseen
 hand flicks on. And trials,
pumpkin-colored ships in the street, disturb the busman's
 accident long ago,
having no sense of humor, or just barely. The frightened
 sleep in parks,
though motionless palm fronds announce a quiet
 evening. You can get over
bouts of humor best by not going indoors
when the moon is full. The lion stood by the bridge
so long it might have been a sculpture, but in the end
 loped sheepishly away.

And we have to figure out what these coins mean, not knowing the language.

On Frank Faulkner
1990

I first saw Frank Faulkner's paintings in about 1975, when a friend visiting from California took me to his SoHo studio. What struck me immediately was how remote from current art-world fashions his work was. Those obsessively patterned, mazelike diagrams studded with knobs of glistening plastic were more like African ceremonial masks or shields than, say, "pattern painting," a short-lived flirtation with decorative flourishes that was in any event still several seasons away. When it did finally emerge as a movement, some might have been tempted to situate Faulkner's work on its (multicolored) fringes. Yet pattern painting, like so many American art movements, came with a barely hidden moral agenda attached: low equals high, Rauschenberg erases de Kooning, wallpaper is as good as Matisse. In other words, you're not allowed to enjoy the gilding unless you swallow the didactic pill as well.

Faulkner's work, which has evolved slowly and steadily from its beginnings, has no pills and no gilding. If it resembles any contemporary school, it might be minimalism in music, which appears to have undergone a similar evolution. First conceived by Philip Glass and Steve Reich as, perhaps, an antidote to both too-strict and too-free forms of musical expression (Babbitt and Cage, for instance—not that there was anything wrong with *them*, but art has to progress somehow, and this

usually involves stepping on toes and having one's own stepped on later on). This reaction was, of course, not without a didactic purpose of its own, but something funny happened on the way to post-minimalism—the music began to complicate itself, contradict itself, so that today it has come full circle back to the randomness and the sometimes-resulting richness of *all* music. John Adams's singular (and singularly unlike) recent compositions, *The Wound-Dresser* and *Fearful Symmetries*, are but two examples among many. But in order for these outbursts of fresh invention to come about, the composer had to approach them through the back door of a self-imposed discipline—in this case minimalism. Each succeeding generation of artists is obliged to reinvent the wheel—to discover the art that is always there with its own newly crafted tools.

Frank Faulkner, it seems, has imposed similar disciplines on his own work, with similar results. The hieratic patterning, the horror vacui, the compulsion to cover every inch of canvas with a predetermined pattern are still there, as is the idea of the artist as shaman-like image maker chained to the canons of his craft.

Over the years, however, the art has changed as gradually and as subtly as the linear decoration of primitive pottery slowly congeals and recasts itself into blocks of pattern over a period of thousands of years. The schematic underpinning is still there, but in these late works it can explode into something almost—but not quite—like brilliant chaos, as in *Miasma*. Here the complexity

of the given task wanders off into unexpectedness in the very act of fulfilling itself. And with this comes a new and almost offhand barbarous richness of color and *matière*. The patient craftsmanship of the equatorial ex-voto maker has metamorphosed into the ferocious splendor of a Scythian goldsmith's or armorer's work: artifacts meant to allude to the cruelty of the hunt, to passionate and savage conquests, even as they are being ritually used.

Just as his titles now suggest vast geographical reaches (*Continent*, *Sargasso*), the paintings themselves now evoke huge maps with minds of their own, or labyrinths with directional indications too infrequent to help one find one's way out of the maze but sufficient to make one want to plunge into it. *Continent*, for instance, thrusts its checkered lozenge shapes at us as insistently as a continent would press itself on an explorer. The outlines are clear, in general, but there are stray paths and counter-proposals that throw us off-balance, even though on closer inspection they, too, seem to be traces of a schema so large that we see only fragments of it. But for the enchanter in whose mind they exist complete, this is a matter of indifference: he knows what he knows. Meanwhile what counts for us is the gorgeous and seemingly arbitrary fluctuations of a visible dream whose roots are nonetheless deeply anchored in reason. They are like a visual demonstration of Blake's proverb, "Eternity is in love with the productions of time."

Light Turnouts

Dear ghost, what shelter
in the noonday crowd? I'm going to write
an hour, then read
what someone else has written.

You've no mansion for this to happen in.
But your adventures are like safe houses,
your knowing where to stop an adventure
of another order, like seizing the weather.

We too are embroiled in this scene of happening,
and when we speak the same phrase together:
"We used to have one of those,"
it matters like a shot in the dark.

One of us stays behind.
One of us advances on the bridge
as on a carpet. Life—it's marvelous—
follows and falls behind.

On Ellsworth Kelly
1992

When Ellsworth Kelly arrived in Paris in the fall of 1948 to study art on the GI Bill, he soon found himself, like so many other aspiring American artists who flocked to France after the war, ignoring the stolid art instruction that prevailed there at the time, and looking elsewhere for the stimuli he needed. These were everywhere, as it turned out: you just had to open yourself to them. Finding "all art since the Renaissance too man-oriented," he went in search of "the object quality." It could be located in anything from ancient Egyptian and Chinese artifacts to the random scratches on a masonry wall or the pattern of tiles in the floor of the American Hospital at Neuilly. "The forms found in the vaulting of a cathedral or even the splatter of tar on the road seemed more valid and instructive and a more voluptuous experience than either geometric or action painting. Instead of making a picture that was an interpretation of a thing seen, or a picture of invented content, I found an object and 'presented' it as itself alone."

Of course Kelly could have made this discovery anywhere, but in fact it came to him only after he transplanted himself to Paris, a city whose creative energy immediately engages the visitor, even at times when not much in the way of art is being produced there, as was the case during Kelly's Paris years. At that time the city was a gray and somewhat seedy place: Malraux's grandi-

ose project of cleaning every Parisian facade was still more than a decade away. No matter: the grayness was conducive to meditation, and it was the explicit ephemera of everyday life as much as the certified monuments that helped generate it. This particular *Stimmung* has been captured beautifully by R. B. Kitaj in his painting of wistful customers at an outdoor cafe called *The Autumn of Central Paris*. In this attenuated medium one could be handed a sudden insight like a gift that, if one were creating, could grow and flower in unexpected ways.

For Kelly this happened over and over again, but most importantly perhaps in his sudden "take" on a window in Paris's Museum of Modern Art, then housed in a dreary and decaying pile called the Palais de Tokyo, which had been built for the 1937 Exposition. Suddenly finding his attention drawn from the art on display to the unremarkable grid of a window, he went on to "appropriate" this form, reproducing it with two canvases and a wood frame. "I realized that painting as I had known it was finished for me. The new works were to be objects, unsigned, anonymous."

This isn't far from John Cage's dictum that "a work of art shouldn't express anything; it should rather imitate the forces of nature" (as he put it in a radio interview I heard recently). Kelly and Cage met, appropriately, by chance, in 1949, when the composer and Merce Cunningham happened to be staying for a few days at the modest hotel on the Île Saint-Louis where Kelly was living at the time. They were enthusiastic about the work Kelly

showed them, and he feels this brief encounter gave his work a "touch." Just as Cage's music was soon to be dictated entirely by chance operations, Kelly would soon produce chance-inspired (if not chance-determined) pictures suggested by a dream he had. "I made a drawing of many ink strokes, which I cut up into twenty squares and placed at random in a four-by-five grid. When the drawing/collage was made into a painting the squares were cut from wood, and after the twenty squares were painted, I spent much time rearranging the panels, deciding the work had an infinite number of ways it could be seen, and should be called *A Painting with Infinite Variations*. Finally, only the original arrangement of the drawing/collage pleased me, so the panels were joined and have remained so." Chance did however determine the final look of works that followed, such as the *Spectrum Colors Arranged by Chance* series. Even here, however, Kelly is managing chance, however minimally, since it was he who had the idea for the work and provided its raw materials (squares of colored paper in the latter instance), just as Cage had acknowledged minimal manipulation in his aleatory works, or at any rate preexisting conditions: the chance operations that produced his *Music of Changes* were still limited by the eighty-eight keys of the piano keyboard. For Kelly, too, randomness is a means rather than an end: as he has said, "I found an object and 'presented' it as itself alone."

"Presenting" is obviously something more than raising a curtain or shining a spotlight: at the very least it is

an act of excluding all the other subjects that could have been presented instead of this one. The wonder of all the works that resulted from Kelly's collection of potential subject matter in Paris in those days (tar on the sidewalk, shadows on a metal staircase, an Egyptian funerary figure) is how he came to exclude all the other material with which he was constantly bombarded. Why this patch of peeling masonry and not that other one? But he has never suggested a democracy wherein all "subjects" are created equal. Rather he is an elitist, if an atypical one: "Everywhere I looked, everything I saw became something to be made, and it had to be exactly as it was, with nothing added. It was a new freedom: there was no longer the need to compose. The subject was there already made and I could take from everything. It all belongs to me.... It was all the same: anything goes." Right, anything but not *everything*. Only a handful of objects are destined to be thus transfigured by being left as they are. I suspect that in this burgeoning period of his art the limiting force was Paris itself, that dome of intuitive appreciation of one's own powers of observation, a specific place and time where "some tone on the hills or the sea is choicer than the rest; some mood of passion or insight or intellectual excitement is irresistibly real and attractive for us,—for that moment only" in Pater's famous formulation, and where, as Gertrude Stein said, Americans can discover what it means to be American. One can never predict what form the generating impulse will take: in my case (my own years in Paris came just after

Kelly's) I found my poetry being more "influenced" by the sight of the Paris phenomenon of clear water flowing in the street gutters, where it is (or was) diverted or dammed by burlap sandbags moved about by workmen, than it was by the French poetry I was learning to read at the time.

Just as Kelly in his chance-inspired works never proposed, or meant to propose, a concatenation of everything all at once, but a single situation, randomly "presented" and left to speak for all the others whether or not it is representative of them, so in his drawings of flowers, at first so different from his increasingly monolithic abstract paintings and sculptures, the simplicity of line, sometimes drawn without lifting his hand from the paper throughout the course of a drawing, speaks of specificity rather than emblematic generality. "They are not an approximation of the thing seen nor are they a personal expression or an abstraction. They are an impersonal observation of the form." Which, again, is close to Pater's "Not the fruit of experience, but experience itself, is the end."

One might take issue with Kelly's denial that the drawings constitute a personal expression—who but he, after all, could have done them? But it is certainly true that they are situated somewhere between expression and abstraction—in a vortex of tension that is the locus of all of Kelly's art. Here the flatness that wants to be volumetric even as it denies any such intention can still be itself, as it is in some of the ever so slightly curved planar sculp-

tures. The eye reads the space enclosed by the line as flat, even though it knows that leaves bulge and tendrils curl toward and away from the viewer.

Kelly's whole enterprise is an example of how the discoveries of the French impressionists have come full circle and in doing so have taken root in America while withering in France. The discovery that whatever is offered to the eye at a given moment is "the end" ("experience rather than the fruit of experience") somehow sprang up in America just after the Second World War, when great works of art were of course still being produced in France by Picasso, Matisse, Bonnard, and others but where the ferment that ended in 1914 never erupted again. The admiration of Michel Seuphor, the leading critic and theoretician of French geometrical abstraction, no doubt pleased Kelly, but the work of the artists Seuphor championed meant little to him. In much the same way, Cage and Boulez briefly admired each other's work in the postwar period but soon parted ways—at any rate Boulez went *his* own way after noisily fulminating against aleatory music. The inexperienced eye might for a moment notice little difference between Kelly's *Red Yellow Blue White and Black* and a painting by Dewasne or Domela, just as a listener might at first mistake Boulez's *Second Sonata* for Cage's contemporaneous *Music of Changes*. But further inspection proves them to be profoundly unlike. The European works in question are the product of ideas—of a fully reasoned, altruistic infrastructure whose presence can be felt even

when it goes momentarily out of focus. With Kelly and Cage the "ordering" principle paradoxically is chance, improvisation—that is, whatever looks right or sounds right at a given moment does so because it has been chosen at random. The merits of both approaches can and have been argued, and Americans have been criticized for what looks to Europeans like anti-intellectualism. Yet whatever it is, it embodies an American openness that has been with us at least since Emerson, who said that "Men are better than their theology" and that "He is great who is what he is from Nature, and never reminds us of others." Both statements seem somehow to characterize Kelly, an artist who merely lets himself become the channel through which what is viable is summoned to appear, and for whom, in Emerson's words again, "the reward of a thing well done is to have done it."

From Estuaries, from Casinos

It's almost two years now.
The theme was articulated, the brightness filled in.
And when we tell about it
no wave of recollection comes gushing back—
it's as though the war had never happened.
There's a smooth slightly concave space there instead:
not the ghost of a navel. There are pointless rounds to
 be made.

No one who saw you at work would ever believe that.
The memories you ground down, the smashed perfection:
Look, it's wilted, but the shape of a beautiful table remains.
There are other stories, too ambiguous even for
 our purposes,
but that's no matter. We'll use them and someday,
a name-day,
a great event will go unreported.

All that distance, you ask, to the sun?
Surely no one is going to remember to climb
where it insists, poking about
in an abstract of everyday phrases? People have better
things to do with their lives than count how many
bets have been lost, and we all know the birds were
 here once.
Here they totter and subside, even in surviving.

In history, the best bird catchers were brought before
 the king,
and he did something, though nobody knows when.
That was before you could have it all
by just turning on the tap, letting it run
in a fiery stream from house to garage—
and we sat back, content to let the letter of the thing
 notice us,
untroubled by the spirit, talking of the next gull to fly away
on the cement horizon, not quibbling, unspoken for.

We should all get back to the night that bore us
but since that is impossible a dream may be the only way:
dreams of school, of travel, continue to teach and
 unteach us
as always the heart flies a little away,
perhaps accompanying, perhaps not. Perhaps a
 familiar spirit,
possibly a stranger, a small enemy whose boiling point
hasn't yet been reached, and in that time
will our desire be fleshed out, at any rate
made clearer as the time comes
to examine it and draw the rasping conclusions?

And though I feel like a fish out of water I
recognize the workmen who proceed before me,
nailing the thing down.
Who asks anything of me?
I am available, my heart pinned in a trance

to the notice board, the stone
inside me ready to speak, if that is all that can save us.

And I think one way or perhaps two; it doesn't matter
as long as one can slip by, and easily
into the questioning but not miasmal dark.
Look, here is a stance—
shall you cover it, cape it? I
don't care he said, going down all those stairs
makes a boy of you. And I had what I want
only now I don't want it, not having it, and yet it defers
to some, is meat and peace and a wooden footbridge
ringing the town, drawing all in after it. And explaining
 the way to go.

After all this I think I
feel pretty euphoric. Bells chimed, the sky healed.
The great road unrolled its vast burden,
the climate came to the rescue—it always does—
and we were shaken as in a hat and distributed on
 the ground.
I wish I could tell the next thing. But in dreams I can't,
so will let this thing stand in for it, this me
I have become, this loving you either way.

Playlist II
1991–1993

1991

Gavin Bryars—*After the Requiem*—Bill Frisell, Evan Parker, and others (ECM)

Arvo Pärt—*Miserere*—The Hilliard Ensemble, Orchester der Beethovenhalle Bonn (ECM)

Einojuhani Rautavaara—*Piano Concertos 1 & 2*—Leipzig Radio Symphony Orchestra, Max Pommer, Bavarian Radio Symphony Orchestra, Jukka-Pekka Saraste, Ralf Gothóni (Ondine)

Erik Satie, John Cage—*Socrate, Cheap Imitation*—Hilke Helling, Deborah Richards, Herbert Henck (WERGO)

Giacinto Scelsi—*Suite No. 8 «Bot-Ba» (Tibet), Suite No. 9 «Ttai» (Paix)*—Werner Bärtschi (Accord)

Anton Webern—*Complete Works Opp. 1–31*—Pierre Boulez, Juilliard String Quartet, London Symphony Orchestra (Sony Classical)

1992

Louis Andriessen—*De Staat*—Schoenberg Ensemble, Reinbert de Leeuw (Elektra Nonesuch)

Elliott Carter—*Concerto for Orchestra, Violin Concerto, Three Occasions*—Oliver Knussen, London Sinfonietta, Ole Bøhn (Virgin Classics)

Marc-Antoine Charpentier—*Les Arts Florissants*—Ensemble Vocal et Instrumental "Les Arts Florissants," William Christie (Harmonia Mundi)

Arthur Lourié, Alexander Mosolov, Nikolai Roslavets—
Rediscovering the Russian Avant-Garde, 1912–1925—
Sarah Rothenberg (GM)

Giacinto Scelsi—*Bot-Ba*—Marianne Schroeder (hat ART)

Stefan Wolpe—*Quartet No. 1, Piece for Two Instrumental
Units, Drei Lieder von Bertolt Brecht*—Parnassus, Anthony
Korf (Koch International Classics)

1993

Ferruccio Busoni—*Arlecchino, Turandot*—Kent Nagano,
Orchestre de l'Opéra de Lyon (Virgin Classics)

Morton Feldman—*For John Cage*—Yasushi Toyoshima,
Aki Takahashi (ALM)

Gabriel Fauré, Claude Debussy, Camille Saint-Saëns—
French Violin Sonatas—Chee-Yun, Akira Eguchi (Denon)

Domenico Scarlatti—*The Celebrated Scarlatti
Recordings*—Vladimir Horowitz (Sony Classical)

Alfred Schnittke—*Quasi Una Sonata, Piano Trio, Piano
Sonata No. 2*—English Chamber Orchestra, Irina
Schnittke, Mark Lubotsky, Mstislav Rostropovich (Sony
Classical)

Franz Schubert—*The Last Three Piano Sonatas, D. 958,
959, 960; Three Piano Pieces, D. 946*—Alfred Brendel
(Philips)

On Larry Rivers (I)

1993

Larry has always been out of sync. When the great abstract expressionist painters of the generation before him were building bonfires, he was being Bonnard and finding new things to enjoy in the way of strange female flesh, pubic hair, parrots, sun-filled interiors. And when that movement collapsed he took pains to distance himself from the pop artists with whom he might have claimed some kinship, to his profit; to his credit, he did not: his cigars were light, elegant frothy things with a sense of humor, were at the opposite pole from the cautionary industrial trompe l'oeil of Warhol's Brillo boxes. And when movement followed movement after that with sickening regularity, and young artists were learning to get in early and make a quick killing while the market was high, he continued to go about doing his irritating, messy thing, sometimes dismaying even his admirers with its confusedness, at other times erupting like a volcano of important, usable things as in his history of the Russian Revolution or whatever it's called—he's great on History 101 titles that promise to give you all of Western civilization in return for a few moments of your attention. He has always specialized in being hopeless and making it work for him. Same in his life, he's always been a pain in the ass, a *mauvais coucheur* (bad bedfellow) in any senses of the word, a trial and a sorrow to his friends as he tries to hurt them for their own good, to prove how

much he loves them, a self-appointed Savonarola in reverse, saying and protecting the vanities and the vices, at worst a Dostoevskian buffoon à la Papa Karamazov. And yet, what would we have been without him? In the end, we, his friends, his public, know that life would have been sanitized and dull without the knowledge that Larry was constantly running around in the background, sometimes emerging into the foreground, bouncing back into our awakeness with some new discovery, or something he thinks is a discovery; it doesn't really matter: he has said it is, he's there, there for us when we've run out of inspiration and getting increasingly chafed. He's onto something and he's already building on it, even though that something may be as skewed as his homegrown etymological discoveries. I remember visiting the baths of Pompeii with him when the guide pointed out the caryatids supporting the shelves for the bath towels, and Larry intuited: caryatids—carry—like they're carrying the shelves on their backs—and once again he was off and running. How fortunate for us that he runs off and always comes back to cheer us, to "cheer up our knowing," in John Cage's phrase. For if he didn't exist, we'd have to invent him, which would be no fun. But Larry is, he is fun.

Mutt and Jeff

> "But what he does, the river,
> Nobody knows."
> — Hölderlin, "The Ister"

Actually the intent of
the polish remained well after
the soup was nailed down. Remnants to cherish:
the sunset tie old Mrs. Lessing gave me,
a fragment of someone's snowball.

And you see, things work for me,
kind of, though there's always more to be done.
But man has known that ever since the days
of the Nile. We get exported
and must scrabble around for a while
in some dusty square, until
a poster fragment reveals the intended clue.
We must leave at once for Wabash.

And sure enough, by the train side the blue-
uniformed bicycle messenger kept up easily
and handed me the parcel.
"Ere the days of his pilgrimage vanish,"
I must reflect on exactly what it was he did:
how lithe his arm was, and how he faded
in a coppice the moment the yarn was done.

Still, the goldfish bowl remains
after all these years like an image
reflected on water. It was not a bad thing
to have done what I have done,
though I can imagine better ones, but still
it amounted to more than anyone ever thought
it would. The mouse eyes me admiringly
from behind his chair; the one or two cats
pass gravely over or under my leg from time to time.
The point is there's no bitterness,
not here, nor behind the scenes.

My sudden fruiting into the war
is like a dream now, a dream palace
written for children and others, ogres.
She was braining my boss.
The day bounced green off its boards.
There's nothing to return, really:
Gumballs rattled in the dispenser, I saw
my chance for a siesta and took it
as bluebottles kept a respectful distance.

On Joan Mitchell
1993

I happened to see Joan Mitchell's first show, at a gallery called The New Gallery, in 1952. I was new to New York and the painting of New York was new to me. I wouldn't have known enough to go to the show if a painter friend, Jane Freilicher, I believe, hadn't guided me there, mentioning that this was something one should see. I remember only a sensation of gyrating fan-blade shapes, chilly colors, and an energy that seemed to have other things in mind than the desire to please. I must have seen the large painting called *Cross Section of a Bridge*, since it was in the show. I don't remember it, but when I look at it now in reproduction it sums up the mood of those early pictures: a fierce will to communicate and an equally frantic refusal to make this task any easier for the sender and the receiver of whatever message was being transmitted. A cross-section of a bridge is not going to help anyone get from here to there; at most it will analyze and dissect the structure that would let us do so if it were placed subserviently under our feet rather than flung in our faces, as this confused, wildly flailing aggregate of jagged planes and wiry outline was.

When I got to know Joan in Paris a few years later she had already abandoned this early planar style for a different one that she would continue to practice and perfect throughout her life, and which her name now evokes for us: shaggy, dense forms that might be a haystack or

a coat of burrs *or anything that might suggest these forms*, and the luscious brushwork that confines color amazingly within paint, so that one can never again look at raw pigment squeezed from a tube without wondering where the color is, and where Joan got it from. One's first urge is simultaneously to taste, caress, and roll around in this theater of color; to rehearse its speeches and submit to its rules like an actor following stage directions, loving the coming and going they propose: "going with the flow," a force that is tidal and inescapable once one accepts the terms of engagement. And it is as difficult not to do so as it was difficult not to take Joan herself on her own terms.

For Joan was a tough lady, a hard drinker, hard on her friends and harder on herself. Yet her thorniness made you want to hug her, as one thinks (twice) of embracing a rosebush: such passion is hard to resist, even when it confronts you in uncomfortable ways. A French critic who knows and loves her work recently asked me how I remembered her, and I found myself saying, "She had a knack for putting you ill at ease immediately." He seemed a little shocked by this, yet I meant it as a compliment. It was one of the things that drew you to her, paradoxically. Being shaken up a little, in the context of so much friendly warmth, was invariably a refreshing experience, from which one emerged with new ideas, especially since one usually saw her in her studio, with her newest paintings on the walls or the easel.

Joan and I once collaborated on a book, a luxurious limited edition of silk screens by her and poems of mine,

including a poem to which I gave the Mitchell-esque title "Black Violets." It was in 1960, a period when I was living in Paris and feeling undernourished by the foreign language that swirled around me and missing the tonifying vitality of the art scene in New York. There were only a few artists working in Paris whose work gave me the charge I wanted and needed, and fewer still with whom I could meet and discuss painting and poetry (Joan was a passionate reader of poetry) on a regular, almost weekly basis. Lunch in her studio in the dull rue Frémicourt was almost a *table ouverte* affair, prepared by her cook and confidante and shared with Jean-Paul Riopelle, two ankle-nipping Skye terriers, and whatever French or American waifs happened to be passing through. Much wine and alcohol would be consumed, after which Joan would begin to work in earnest and I would go home to take a nap. This was how I lived during a period when I felt more uncertain than usual about my own work, and which my frequent contacts with Joan helped me through. I've forgotten the poem that I called "Black Violets," but I can remember my excitement watching Joan's steady advances in painting, which somehow suggested the phrase. For her paintings typically conjured up a landscape in which one or more elements were missing or askew, but where everything hung together, just as violets aren't really black but could just as well be. Looking at those large sixties paintings one tasted and smelled fresh dampness and turned earth, blinked at stabs of sky and colors fantastically inappropriate to it, though right

for the painting; your first impulse was to wipe your shoes and inspect your knees for grass stain, whose unique color turns up frequently in her works of that time.

It's now possible, thanks to a copiously illustrated monograph on her work by Michel Waldberg, to follow her progress as a painter—something that was difficult before, since works from one period would appear to resemble those from previous periods unless one actually had them before one, in which case the differences can seem enormous. Her development is as hard to seize as a single painting of hers is hard to take in when you are looking at it: it approaches and retreats at the same time, a shimmer that simultaneously taxes and enchants one's seeing. What is remarkable is how often she seems to reach a pinnacle that seems definitive—until the next one comes along; and how each new level is palpably a further stage yet by no means diminishes those which have preceded it. The series of immense and ambitious paintings done in 1983 and 1984 called *La Grande Vallée* is one obvious example. They have a new monumentality and spaciousness, even an awe-inspiring emptiness: with a more limited palette than usual, greens and blues especially, and stretches of paint less peopled with events, she has created a parallel world with something of the expansive depth of "her" valley, that of the Seine at Vétheuil, or that of Bruckner symphony: a distillation of vast life.

These are followed by the astonishing *Between* series: smaller paintings whose tangled daubs of jewel-like

colors seem to bring a detail of that infinity up close, as though through a zoom lens, and in so doing offer an alternative way of getting at and absorbing the jungle of phenomena we call the world for lack of a better term. Darkly luminous, they bring to mind Dylan Thomas's phrase "altarwise by owl-light"; at the same time they don't suggest private corners suddenly illuminated, but hitherto unnoticed regions of the soul brought forward to stand in for the whole entity, fragments finally given their due as emblems of completeness. Next come paintings whose titles have valedictory overtones, such as *Then, Last Time* (of which number IV seems an especially strong evocation of mourning) and *A Few Days*—number II is subtitled *After James Schuyler*, and alludes to that poet's poem of the same title, which begins: "A Few Days / are all we have. So count them as they pass. They pass too quickly ..."

These intimations of mortality are, however, bright and full of particulars, and lead to the truly magisterial work of her last years, in which all the levels of achievement seen so far are captured, celebrated, and expanded, in pictures of enormous freedom and authority. All of her signature marks are present: the heavy, electric scribbles that are like rain (and occur in a painting called *Rain*) or like the colored spines of books, that strangely summarize their contents; the stacked strata of colors (as in *Champs*), where rich darks fail to cancel out blazing underpainting or else compete with other darks of a different intensity; the discrete explosions of different colors

that suggest disorderly bouquets in the *Sunflowers* series; the ability to create a form as casual but viable as a pile of raked leaves (*Phyllis*); or the truly amazing large canvas *Ici*, done in the last years of her life, which seethes with songful life-affirming color, spattering brushwork, and zones of color linked in a swaying chain that recalls the figures in Matisse's *La Danse*—not that they are remotely figural, but their celebratory connectedness echoes the summit of joy expressed in that painting.

Ici—Here!, Mitchell seems to be saying at the end of her life, is where life is, is what it is—one of those truths under one's nose that one ignores for that reason but which, in the right circumstances, can transform itself from truism into palpitating reality. Of course this isn't the first time Mitchell made that discovery, but its coming at the end reminds us again how often she has done her best and then done even better than that, without greatly altering the rules of the game, only redefining them a little more precisely each time, hundreds of times. "To go is to go farther," wrote the poet Kenneth Koch. Joan Mitchell seems to have lived that truth literally, and if it is tragic for us that she can now go no farther, we are still left with a body of work whose will to continue stays with us, helping us to "go farther" along the common way that all of us travel.

The Improvement

Is that where it happens?
Only yesterday when I came back, I had this
diaphanous disaffection for this room, for spaces,
for the whole sky and whatever lies beyond.
I felt the eggplant, then the rhubarb.
Nothing seems strong enough for
this life to manage, that sees beyond
into particles forming some kind of entity—
so we get dressed kindly, crazy at the moment.
A life of afterwords begins.

We never live long enough in our lives
to know what today is like.
Shards, smiling beaches,
abandon us somehow even as we converse with them.
And the leopard is transparent, like iced tea.

I wake up, my face pressed
in the dewy mess of a dream. It mattered,
because of the dream, and because dreams are by
 nature sad
even when there's a lot of exclaiming and beating
as there was in this one. I want the openness
of the dream turned inside out, exploded
into pieces of meaning by its own unasked questions,
beyond the calculations of heaven. Then the larkspur
would don its own disproportionate weight,
and trees return to the starting gate.
See, our lips bend.

On Jane Freilicher (I)

1995

Ever since she saw the first panel called *Le Mezzetin* in The Metropolitan Museum of Art a number of years ago, Jane Freilicher has been fascinated by the gallant figure of Watteau's guitar player. A loose-limbed early fifties homage to the painting added a note of violence (these were abstract expressionist times, after all) to the already odd mixture of weariness and frivolity in the Watteau. What is it about this languishing figure with his abandoned pose and fancy costume that intrigues her? He's not someone with whom one identifies readily, as one does with Watteau's more celebrated Gilles, an emblem of all the sad clowns of history. The guitar player is romantically inclined but not strongly so, perhaps aware that his serenade will not be crowned with success. He seems, in fact, to be recoiling from any possibility of it.

Like his creator, of whom Pater famously wrote, "He was always a seeker after something in the world that is there in no satisfying measure, or not at all," Watteau's guitar player appears to have come to terms with the unsatisfactoriness of costumes, playacting, and nocturnal music making, while continuing to propose these alternatives to mundane existence. Freilicher, too, is enamored of things that exist in the world in no satisfying measure, and she offers an intoxicating array of them in her new exhibition at the Fischbach Gallery, which includes several studies of the guitar player. In

one painting, he even appears twice. Besides the musician there is the intermittent presence of a parrot, lovely in a coat of gray feathers that Watteau would have appreciated, who also trails associations of *vanitas*. There are flowers like godetia, clusters of small individual blossoms of an intense pink, placed in one painting next to a glass of what looks like cranberry juice, whose assertive red can't intimidate the flower's paler vibrancy. There is a landscape under a light coating of snow, such as falls toward the end of winter on eastern Long Island where the scene was painted; again the note is one of transience. And there is the light: invisible because seen only on the objects it picks out, as a truffle with no flavor of its own imparts flavor to the food it comes in contact with.

The light is almost a character, a player in the game like the musician and the parrot (and, like them, not invariably present). Freilicher gives her canvases a thin wash of Venetian red before painting on them, and it's partly this that has the effect of muffling or deadening the light or even draining it, while replacing it with an alternative one that announces a remarkable day, or moment; a time when light stood still to inform us that things really did look this way once, that this really happened, that it took precedence over all previous incarnations of itself.

We've all seen something approaching this kind of light, for instance in the grayish-pink winter twilight that sometimes presses down on New York, or the brassy-yellow, exhausted light at the end of summer

when goldenrod blooms almost as an explicit example of this fugitive tint. But the light's presence in the painting seems the result not of an impressionist attempt to seize a momentary ambience, but rather of Freilicher's determination to impose her own revisionist light on what was after all a mere suggestion in nature.

For me this is a major part of the excitement of her work and of these new paintings in particular. The more one looks the more one becomes aware of radical decisions the painter has made—decisions to reduce the size and authority of this particular object and in so doing enhance this other one, which at first had seemed insignificant or ill-defined in comparison. There are games of perspective that sneak up on you unawares, and truly original departures from sense like the tabletop in *Summer Flowers, Urban Dusk* (a title that summarizes the piquant contradictions throughout), that floats in space like a magic carpet, unsupported by anything as banal as legs.

The upshot of all these sly, at times barely noticeable revisions in the subjects that confronted her is a radical overhauling of what was seen, which paradoxically comes through as more "like" than the originals could ever have hoped to be. With all their reassuring familiarity, the paintings are really revolutionary, given that lasting revolution comes about only as the by-product of small events that may go unremarked at the time they happen. Despite elements that on occasion can seem refractory, they are full-blown revelations with an

authority that mere waywardness could never muster. They look the way they do because they are in the process of becoming, even while you take them in. And since the process is an ongoing one there will always be passages that are disconcerting, alongside others whose "rightness" soothes and flatters the eye. It's a small price to pay, if indeed it is one, for her kind of advanced realism, which hasn't congealed on the canvas but is still alive and thrashing, almost but not quite pinned down.

No Longer Very Clear

It is true that I can no longer remember very well
the time when we first began to know each other.
However, I do remember very well
the first time we met. You walked in sunlight,
holding a daisy. You said, "Children make unreliable
 witnesses."

Now, so long after that time,
I keep the spirit of it throbbing still.
The ideas are still the same, and they expand
to fill vast, antique cubes.

My daughter was reading one just the other day.
She said, "How like pellucid statues, Daddy. Or like a ...
an engine."

In this house of blues the cold creeps stealthily upon us.
I do not dare to do what I fantasize doing.
With time the blue congeals into roomlike purple
that takes the shape of alcoves, landings ...
Everything is like something else.
I should have waited before I learned this.

On Robert Mapplethorpe
1996

Mapplethorpe's flower pictures seem to be in danger of getting lost in the uproar that will probably always surround his name, though in my opinion they are far from being a minor interlude to his career. Together with the late self-portraits, they are one of its major moments. They have always been problematic, however, and not least so to the photographer himself. Again and again, when interviewers brought up the subject, he would insist on his indifference to or even dislike of flowers. "I don't love flowers and I don't like having them," he said in a conversation with the critic Anne Horton.

> HORTON: "What don't you like about living with them ... the bother of watering them?"
> MAPPLETHORPE: "Watering them and dripping on the floor."
> HORTON: "And watching them die?"
> MAPPLETHORPE: "And watching them die and feeling guilty about them. I can't have part of my life devoted to flowers. But I can photograph them and get excited about photographing them.... I'll sort of force myself to photograph them before they die because I know I can get a good picture of them."[1]

His concern for the flowers is almost touching; his dislike is at least partly rooted in sympathy; he doesn't

want the responsibility for their dying. This scarcely jibes with the image of Mapplethorpe as a calculating exploiter of his subjects. It does, however, coincide with his fanatical concern with perfection ("I'm not after imperfections") and his equally obsessive horror of decay and death. Not only does he want to be absolved of collusion in the flowers' death but he senses the possibility of this outcome as a kind of betrayal. From there it is only a step to wishing to take revenge on the flowers for the transience of their perfection. What better way to do this than to reveal the cruelty that lies behind their seductive appearance? "I think the flowers have a certain edge.... I don't know if 'nasty' is the right word—if you look at the picture of the orchid, to me it is a kind of scorpion— it has a sharp edge to it." Having thus revealed the nature of their mutual love-hate relationship, he expands on it: "I get something out of the flowers that other people don't get.... I love the pictures of flowers more than I love real flowers."

Mapplethorpe's chosen environment was far from the light of day, either in his darkened studio or the darkness of the S&M bars where he hung out almost every night. Can one feel sympathy for an artist who hates not only flowers but sunlight too? Well, yes. Not everyone appreciates the light of the sun. A sunny day in winter calls attention to the moribund landscape; on summer evenings, too, the excess of light can be unbearable, as Thomas De Quincey noted in his *Confessions of an English Opium-Eater*: "I find it impossible to banish the thought

of death when I am walking alone in the endless days of summer." And there is also something wearying about flowers as art objects. Their extreme perishability makes them memento mori without any intervention on the part of the artist. In seventeenth- and eighteenth-century Holland, painters like Ambrosius Bosschaert and Rachel Ruysch built up towering structures of flowers, often using varieties that would not have been in season at the same time; the monumentality of their volume is everywhere undermined by their fragility. Snails and caterpillars, creatures "of the earth, and intolerably earthy" in Vernon Lee's phrase, are very much at home here, reminding us of the precariousness of life. In the nineteenth century, Henri Fantin-Latour was as obsessive about capturing the precise moment of ripeness of bloom as Mapplethorpe would be in the twentieth; luscious as his paintings are, they radiate anxiety. Odilon Redon's otherworldly bouquets already have one eye on eternity, while the young Piet Mondrian was drawn to flowers that were fast fading or even dead.

So there are precedents for the chilly negativism one senses in Mapplethorpe's flower photographs. But their mood is negative for another reason as well: they are only one aspect, and an undernoticed one, of an oeuvre best known for its lurid depictions of violent sex. Scenes of fist-fucking and urine drinking, idolatrous studies of nude black men with huge penises (Mapplethorpe was looking for perfection here too: "If I photograph a flower or a cock, I'm not doing anything different"), are what

has made his name a household word, and, at least in certain households, a synonym for all that is wayward and "degenerate" in contemporary culture. The fate and repercussions of the traveling show of his work, *The Perfect Moment*, are well known. Of course, the flower photographs are not what made him simultaneously famous and unacceptable. They are, in the words of one of his dealers, "the tip of the iceberg." But because he is fashionable, because there is tremendous demand for his work and because so much of it cannot be shown in public, these presumably innocent photographs have been summoned to stand in for the others. It is impossible to look at them and ignore their context, and so they have taken on a further ambiguity: they are, in effect, calling attention to the pictures that are hidden from view. Like fig leaves for absent genitalia, they point to the scandal of what is not there.

This is perhaps an unfair burden for them, and one that, before the posthumous hullabaloo, wasn't in the original plan; at most Mapplethorpe was trying to make some money to finance other work that mattered more to him. He tried this in various ways, with fashion photography and celebrity portraits; once he even covered a chic house party in the Bahamas. The latter assignment was not a success, and Mapplethorpe loathed the result, not just because he was forced to forgo the strictly controlled studio conditions but because, as he repeatedly said, he was not a voyeur. This statement can seem strange coming from the photographer of scabrous

sexual vignettes like *Jim and Tom, Sausalito*, but in fact it isn't: the silent "trust" that Arthur Danto cites as a vital ingredient of these exchanges between model and photographer is always implied. Even when not entirely immobilized, the figures have an iconic seriousness that is moving, regardless of the supposed squalor of the sex acts being recorded. Ingrid Sischy once tried to interest a publisher of pornography in Mapplethorpe's work only to have him refuse to look at it: "I know those pictures," she reports him as saying. "I've never liked them. They're so personal." Yet most pornography, dehumanizing though it may be, is positively clubby compared to Mapplethorpe's sexual panopticon. Eros has never seemed more generic, more mute.

In the last years of his life, his preoccupation with lighting became an obsession. His friend Lynn Davis recalls him asking for stronger and stronger light, to the point where you felt boxed in by power packs when you sat for a portrait. His sitters had to be elaborately made up and coifed; the concentration of light on their faces blots out wrinkles, producing an eerie marmoreal glow. Indeed, his still lifes now included marble busts whose whiteness is dazzling, and rigid arrangements of fruit and pottery with shadows of venetian blinds striping the wall behind. The artificial atmosphere is often claustrophobic, but there is no denying its provocation, which, subject matter aside, is even more shocking than that of the erotic pictures. Still, there are those who have no problem with Mapplethorpe's sexual imagery who find

his work generally cold and empty. Without the context of scandal, does he even exist as an artist? And aren't many of the other works that complete his oeuvre a hairbreadth away from classy commercial photography?

I think that the malign brilliance of his erotic pictures is present throughout, and nowhere more than in the portraits of flowers, impassive but somehow conspiring in their own corruptibility. Their chic glossy-magazine ambience heightens the drama. We've all turned the pages of these magazines, ogled the luxury goods, envied the rich and famous, and then closed them newly conscious of our own mortality. *Vanitas vanitatum.* O rose, thou art sick!

Mapplethorpe approached flowers in the same way as his other subjects: by isolating them. Elaborate bouquets like those favored by the Dutch flower painters don't interest him, though he could produce an atypically sensual work like the photo of a mass of roses, wisteria, carnations, and lilies of the valley that seems to float in midair. Usually, though, the flowers will be all one kind, as in a vase of tulips, more disheveled and past their prime than he usually allows his subjects to get, here perched perilously on the edge of a table; one tulip at far left is about to swan dive into the abyss. It is one of Mapplethorpe's most haunting images. Another is a shot of a flat of tulips, a rare example for him of flowers that are still rooted and growing rather than cut, though they too seem in extremis. Their season will be short.

The most powerful photos are those in which he focuses on a single flower or just a few, pinning them almost cruelly under the lens. A bunch of carnations jammed into a constricting glass cylinder is one of many that hint at the voluntary constraints of s&m. Baby's breath, used by florists as filler in bouquets, looks almost startled to be the only subject in its frame, and its sparseness suddenly turns monumental. In another, a single rose placed next to its looming shadow evokes the "invisible worm" that had set its sights on Mapplethorpe as well. Even more highly charged are some calla lilies teasing phallic pistils, perhaps derived from Georgia O'Keeffe, but to which he imparts a dangerous eroticism of his own.

It's when he used color, which seems like such an unlikely medium for him (and which strangely complements the austere limpid blacks of the late self-portraits), that Mapplethorpe really triumphs. Perhaps all the darkness and grit of his earlier work were a preparation for these sumptuous yet demonic explosions of light and light-saturated forms. The great white calla lily, whose horizontal lines serve as a foil to its proud gold erection, strikes an uncharacteristic jubilant note. It is an invitation to pleasure that will not be rebuffed. Equally forceful and steeped in sexuality are a study of a poppy, bathed in what looks like a sunset glow, and a much-bigger-than-life erect pink tulip against a brown background, placed at the exact center of the frame, with the stem bisecting its bottom edge. There is a sonnet by Théophile Gautier

that boldly begins, "Moi, je suis la tulipe" (I am the tulip) and ends, "Nulle fleur du jardin n'égale ma splendeur, / Mais la nature, hélas! n'a pas versé d'odeur / Dans mon calice fait comme un vase de Chine" (No other flower of the garden equals me in splendor, / But nature, alas!, poured no scent / Into my calyx, shaped like a Chinese vase).

This image of splendor and sterility inextricably fused, of a flower fashioned to appeal to every sense save the one that matters most, is emblematic of these photographs. They are cruel and comforting, calm and disruptive, negative and life-affirming. For all the disillusion it enshrines, his work here paradoxically gives us back joy.

1 Robert Mapplethorpe and Anne Horton, *Robert Mapplethorpe 1986* (Cologne, West Germany: Kicken-Pauseback Galerie, 1986).

Wakefulness

An immodest little white wine, some scattered seraphs,
recollections of the Fall—tell me,
has anyone made a spongier representation, chased
fewer demons out of the parking lot
where we all held hands?

Little by little the idea of the true way returned to me.
I was touched by your care,
reduced to fawning excuses.
Everything was spotless in the little house of our desire,
the clock ticked on and on, happy about
being apprenticed to eternity. A gavotte of dust-motes
came to replace my seeing. Everything was as though
it had happened long ago
in ancient peach-colored funny papers
wherein the law of true opposites was ordained
casually. Then the book opened by itself
and read to us: "You pack of liars,
of course tempted by the crossroads, but I like each
and every one of you with a peculiar sapphire intensity.
Look, here is where I failed at first.
The client leaves. History goes on and on,
rolling distractedly on these shores. Each day, dawn
condenses like a very large star, bakes no bread,
shoes the faithless. How convenient if it's a dream."

In the next sleeping car was madness.
An urgent languor installed itself
as far as the cabbage-hemmed horizons. And if I put a little
bit of myself in this time, stoppered the liquor that is
 our selves'
truant exchanges, brandished my intentions
for once? But only I get
something out of this memory.
A kindly gnome
of fear perched on my dashboard once, but we had all
 been instructed
to ignore the conditions of the chase. Here, it
seems to grow lighter with each passing century. No matter
 how you twist it,
life stays frozen in the headlights.
Funny, none of us heard the roar.

On Joe Brainard
1997

Joe Brainard was one of the nicest artists I have ever known. Nice as a person, and nice as an artist.

This could be a problem. Think of all the artists, especially those whose work you admire, who weren't all that nice. Caravaggio. Degas. Gauguin. De Chirico. Picasso. Pollock. Their art isn't exactly nice either, but the issue seldom arises. In Joe's case, it does. He began around the time that pop art did. With Lichtenstein or Warhol there is a subtext of provocation, though the pop artists generally were too cool, too "down" as we used to say, to let this possibility become anything more than unspoken. In Joe's work, one of his pictures of pansies, for instance, there is confrontation without provocation. A pansy is a loaded subject. So is the effortless, seed-packet look of the painting. But there's no apparent effort on the artist's part to cause stress or wonderment in the viewer. With Joe, our relief and gratitude mingle in the pleasure he offers us. One can sincerely admire the chic and the implicit nastiness of a Warhol soup can without ever wanting to cozy up to it, and perhaps that is as it should be, art being art, a rather distant thing. In the case of Joe one wants to embrace the pansy, so to speak. Make it feel better about being itself, all alone, a silly kind of expression on its face, forced to bear the brunt of its name eternally. Then we suddenly realize that it's "doing" for us, that everything will be okay if

we just look at it, accept it, and let it be itself. And something deeper and more serious than the result of provocation emerges. Joy. Sobriety. Nutty poetry.

There are however no *histoires à l'eau de rose* here. Nor is Joe's book of "I remembers" for family viewing; some indeed seem to require a new rating for "humane smut," though they are so cleverly interleaved among others like "I remember wondering if I *looked* queer" and "I remember the rather severe angles of 'Oriental' lampshades" that one can't say for sure. One is "taken aback." The writing and the art are relaxed—not raging—in their newness, careful of our feelings, careful not to hurt them by so much as taking them into account. They go about their business of being, which in the end makes us better for having seen and lived with them; and better for not feeling indebted to them, thanks to the artist's having gone to such lengths for us not to feel that.

Joe was a creature of incredible tact and generosity. He often gave his work to his friends, but before you could feel obliged to him he was already there, having anticipated the problem several moments or paragraphs earlier, and remedying it while somehow managing to deflect your attention from it. Into something else: a compassionate atmosphere, where looking at his pictures and recognizing their references and modest autobiographical aspirations would somehow make you a nicer person without your realizing it and having to be grateful. It's for this, I think, that his work is so radical,

that we keep returning to it, again and again finding something that is new, bathing in its curative newness.

Joe seems to have taken extraordinary pains for us not to know about his art. Either he would create three thousand tiny works for a show, far too many to take in, or be intentionally less prolific, as he was in the last decade of his life, indulging his two favorite hobbies, smoking and reading novels—mostly Victorian or Barbara Pym's. It's as though in an ultimate gesture of niceness he didn't want us to have the bother of bothering with him. Maybe that's why the work today hits us so hard, sweeping all before it, our hesitations and his, putting us back in the place where we always wanted to be, the delicious chromatic center of the Parcheesi board.

Moderately

"... and as the last will come a sort of moderato part,
(which some is of multiple motions, quick, slow, hampered,
expressive, popular, and peopled speech ...)"
— Stefan Wolpe

The fox brooding and the old people smelling
and the tiebreaker—why did I not think of that?
Why have doubts upon me come? Why
this worldliness?
And I remember no longer at the age of sixteen,
and at the age of seventeen great rollers
eating into night, I uncared for,
stopping among the weeds along the way. Phantom
harvesters hovered. And the great, dry creekbed was a sea
of gravel and stones, the willows were capsized ships,
and none of it was for now.

There is a draught
in the room
and all along the room a sight that is like living
and looking out over a situation. The periods danced
 in a sentence,
and it was my way, the one I chose, even if I didn't choose it,
or like it; was all a coming on,
downpour,
marooned on slopes.

And then the burst of it.
He knew what the world's going to be like I think,
so why the explosions? And caught in the draught,
one fell from darkness, two fell from darkness,
yet another. Maybe that's dust a very fine kind of dust and
 I eat it,
it goes on thrumming, seated in the back row of the
 orchestra,
men masturbating here and there and like I said the clock
is tremendous,
wider than any minute hand or hour hand.

And sheepish it fell out of books:
the land of painful blisses,
the man who stubbed his toe.
All around us pain came sledding in,
and am I like this today, tomorrow, and two
tickets please, the boy and the ruffian come undone,
he was in the park, it was the salutary last person
to hoodwink you and all is well.

There were times a kind of cream was on the jagged borders
or suchlike events and carnivals, and you sat, smiling,
the tongue unleashed from its surroundings. Why was
 I never here?
Why such playacting? Didn't I ever realize the kernels *are*
 deep-seated,
that everyman will overrun his banks just like an
 errant stream,

and cardboard principles be jostled? O who
mentioned this session? What is the matter with truth
 and paying
and all over the paisley fields dominoes are braying,
a matter of luck, or chance, it seems? Who broke the
 next dish?

Why is that man crying,
what does he mean to do? Impertinent, in person,
what does he mean to do,
if these capers are not unusual
and bricks merge with sand, the unusual
at its best as usual, and can't we give up? What
would be the point of continuing? I can't smoke this weed,
I give it back, we are all blessed, commensurates within
a star where many things fit, too many, or not too many,
 whatever
it says about you, whatever saves.

On Trevor Winkfield
1997

If all art aspires toward the condition of music, as Pater wrote, Trevor Winkfield must be counted among the most successful artists of all time. A picture such as his great, recent *Voyage II* totally fulfills that condition: the accuracy and surprises of great music, even its linear un-scrolling, are what confronts us. In fact its effect is the same one a musical score offers a person with some ability for reading music—"sight-reading." Each element in the painting has its precise pitch, its duration. It's as though seeing and hearing merged in a single act, and the "meaning" of the picture were lodged at the inter-section of two of the senses, where one is pleasurably enmeshed, deliciously hindered. The strange erection on the left—a toy windmill with dysfunctional-looking paddles (isn't it from the coat of arms of some ancient and distinguished purveyor of something or other to the royal family?), firmly placed on a pedestal fashioned of bricks, tomatoes, and other less namable objects, is there to cast the authority of its key signature over the frieze on the right, whose elements include a harp, a seagull, some nautical-looking pennants, three table utensils tied together with a red bow, and at the far right some wave-like scallops and stylized drops of water that suggest the musical symbol for *da capo al fine*—go back and start all over again, you idiot! (One of the heroes in Winkfield's pantheon is Satie, author of a short piano

piece called "Vexations" that is meant to be repeated 840 times.) There are also three identical hands, each one a different hue and each holding what may be an empty ice-cream cone (but the third cone has something attached to it that looks like a drooping slice of flan). There are two sculptural heads, one Greek, the other that of a medieval bigwig, Charlemagne perhaps; both are gazing to the left (westward), where the music is coming from, and each is bathed in a different light, for which no source is apparent. These are the describable things, but there are less identifiable ones on which the same amount of objective care has been lavished: three-dimensional grids; strips and colored lines; some stylized leaves at the top; and the Greek figure's curious torso, like a child's top. The colors are those of brand-new but antique toys that have been randomly stacked together: intense pastel greens, banana-yellow, vermilion, chartreuse, Tabasco red, Kool-Aid grape: an assembly whose components ought to "scream at" each other, but which are instead intoning something ineffable, some music of the spheres, though the spheres appear to be rolling around on the floor of a nursery rather than in the heavens.

One could go on listening and describing, "to small purpose and with less effect," in the words of Winkfield's friend, the late James Schuyler. What's clear is that there is no verbal equivalent for taking in the picture, just as there is none for assimilating a piece of music, which is as it should be. The experience in both cases amounts

to what? Perhaps the very *what* in Jasper John's title *According to What*. Something is regulating everything and placing its parts in the proper relation to each other, but that thing is unknown: a blank, though a fundamental one. One reflects on how so much modern art is concerned with dropping things out: the momentous vacancies in Cézanne, in cubist still lifes, in Henry Moore's holes, in Giacometti's erasures. And how an equally important activity has been filling things up again: how the ashen, empty glasses in Picasso's 1910 still lifes are brimming with violent-colored lemonade, Suze and cassis after 1914. Winkfield has somehow managed to combine both of these natural impulses to drain and to replenish, to build and to destroy. And he locates the core of creation precisely there, at the Plimsoll line where the glass is both half empty and half full, where ecstasy means having exactly enough.

Playlist III
1994–1999

1994

Lord Berners—*The Triumph of Neptune, Fugue for Orchestra, Nicholas Nickleby, Trois Morceaux, Fantaisie Espagnole*—Barry Wordsworth, Royal Liverpool Philharmonic Orchestra (EMI Classics)

Gavin Bryars—*The Sinking of the Titanic*—Gavin Bryars (Point Music)

Emmanuel Chabrier—*Piano Works Vol. 2*—Georges Rabol (Naxos)

Frederic Rzewski—*The People United Will Never Be Defeated!*—Stephen Drury (New Albion)

1995

Alban Berg—*Chamber Concerto; Three Orchestral Pieces, Op. 6; Violin Concerto*—Pierre Boulez, BBC Symphony Orchestra, London Symphony Orchestra (Sony Classical)

Charles Ives—*Works for Piano*—Alan Mandel (VoxBox)

1996

David Diamond—*Chamber Works*—William Black, Robert McDuffie (New World)

Bernard Herrmann—*Vertigo (Original Motion Picture Soundtrack)*—Joel McNeely, Royal Scottish National Orchestra (Varèse Sarabande)

Stefan Wolpe—*Passacaglia: First Recordings 1954*—David Tudor, Frances Magnes, and others (hat ART)

1997

Paul Bowles—*The Music of Paul Bowles*—Jonathan Sheffer, Eos Ensemble (Catalyst)

François Couperin—*Leçons de Ténèbres*—William Christie, Les Arts Florissants (Erato)

Robin Holloway—*Third Concerto for Orchestra*—Michael Tilson Thomas, London Symphony Orchestra (NMC)

1998

John Cage—*Music of Changes*—Joseph Kubera (Lovely Music)

Brian Eno—*Music for Airports*—Bang on a Can All-Stars (Point Music)

Jean Françaix—*L'Apocalypse Selon St. Jean*—Christian Simonis, Göttinger Symphonie Orchester (WERGO)

1999

Elliott Carter—*Symphonia, Clarinet Concerto*—Oliver Knussen, London Sinfonietta, BBC Symphony Orchestra (Deutsche Grammophon)

Morton Feldman—*For Samuel Beckett*—Sylvain Cambreling, Klangforum Wien (KAIROS)

Conlon Nancarrow—*Studies for Player Piano* (WERGO)

Girls on the Run
(*Excerpt*)

<center>VI</center>

Nov. 7. Returned again to the exhibition. How strange
 it is that when we
least imagine we are enjoying themselves, a shaft of
 reason will bedazzle
us. Then it's up to us, or at any rate them, to think
 ourselves out of the
muddle and in so doing turn up whole again on the
 shore, impeached by a
sigh, so that the whole balcony of spectators goes
 whizzing past, out of
control, on a collision course with destiny and the
 bridesmaids' sobbing.
Of course, we listened, then whistled, and nobody
 answered, at least it
seemed nobody did. The silence was so intense there
 might have been a
sound moving around in it, but we knew nothing of
 that. Then we came
to. The pictures are so nice on the walls, it seems one
 might destroy
something by even looking at them; the tendency is to
 ignore by walking
around the partition into a small, cramped space that
 is flooded with
daylight. And what if we asked for another spoonful?
 Look, it's down

there, down at the bottom of the well, and we are no
 wiser for it, if
anybody asked. Which they don't. By common consent,
including ours, we are ignored and given the cold
 shoulder to. OK, so it's
all until another day, and we can see quite clearly into
 the needle whose thread is
waving slowly back and forth like a caterpillar, accom-
 plishing its end.
So may it be until the end that is eternity.

VII

The thread ended up on the floor,
where threads go.
It became a permanent thing, like silver—
every time you polish it, a little goes away.
Then the ducks arrived, it was raining.
Such a lot of going around and doing!
Sometimes they were in sordid sexual situations;
at others, a smidgen of fun would intrude on our day
which exists to be intruded on, anyway.
Its value, to us, is incommensurate
with, let's say, the concept of duration, which kills,
surely as a serpent hiding behind a stump.
Our phrase books began to feel useless—for once
you have learned a language, what is there to do but
 forget it?
An illustration changes us.

These were cloistered. They stayed
with us that winter, then went on awhile.
Soon they were back. It was partially time to go out in
the opening.
Some enjoyed it.
Then, if they were true,
the blue rabbit heaped bones upon them. There was no
going back,
now, though, some did go back. Those who did
didn't get very far. The others came out a little ahead,
I think . . . I'm not sure.

Look, this is what I am, what I'm made of.
Am I then to usurp the rose
that blows on time's pediment, wrapping all wisps in
a kind of bundle
of awe? But the sundial smiled in the rain, the stile
beckoned, the sign said it was three miles. In the lane
the parson's
ambulance pestered gold pigtails, who were in for
a shock
when the fox returned smiling, fanning his great tail in
the comet
of the lighthouses the sausages were so concerned about.
Did the game of stealing please any? Here, on the other
side, they were in sync,
their bowls of muesli crooning to the sidelong bats of
evening, and then they were let out

to smoke a cigarette in the meadow. No one knew
 how many
tried to escape, or how many were successful. You had
 to read it
in the evening's news, and by then sea-cows were weary.
They taxed themselves out of existence. Our raft capsized
and they opined the day was bright with promise,
 though shut off
from what really happened. It was time for golf.

This was that day's learning.

Finally when Angela could retrieve her moorings they
 sent the tide out,
but it came back next day, increasingly bizarre.
Bunny and Philip weren't sure they wanted to see more.
 "But you must,"
Angela urged, breathing a little faster. Then they all
 wanted to know why it goes on
all the time, and the preacher answered it was due to bats.
 In the silos. Oh,
I thought you wanted to know, Philip said. We do, but
 other than you there are two
pails formally, and no one can figure out what is inside.
 Indeed? Well I'll
take the plunge, Philip volunteered. He was always a
 brave little kid.

Now it was this side of sunset again. Nobody knew which
 was in error: the stove, or its corset.
After which the elm buds chanced a summer intrusion
and all the nifty year was almost gone. Well isn't that a
 catastrophe, Aunt Clara gurgled,
or are some of you please going to take it outside? Aw, but
 it's raining, someone grumbled,
why can't we stay inside and have school?
Yes but the quitter must go far out into the bogs. It's time
 for the badgers to nest
and who is that coming over the hill this time? It's
Spider, Angela suggested.

But as for leaving you all without a tale to tell, I would
 be daft,
nay derelict, not to insist on where the others have gone.
 Isn't there a place
to stop, that we'll all know about when we come to it?
Yes there is, she said, we'll just all have to back down
into the gloom, and bait our hooks with peanut butter.
Which is what they did
and so they left home that day.

On Rudy Burckhardt (I)

2000

Rudy Burckhardt, a Swiss-born photographer, filmmaker, painter, occasional writer ("Love in Three Acts: A Swiss Play"), and guru (he would have hated the term) to several generations of New York artists and poets, committed suicide on August 1 by walking into a pond near his summer home at Searsmont, Maine. He seems to have arranged his death according to the same offhand, slightly eccentric principles that guided his life. His wife, the painter Yvonne Jacquette, reports that Rudy's middle name was August, and that a couple of days before taking his life he pointed out to her that August 1 is "Swiss independence day." (He had never shown any pronounced fondness for the land of his birth.) At about the same time, he painted a portrait of himself, which he labeled "*The Last Portrait*." When Yvonne asked him about the title he merely shrugged and made an evasive answer. On the evening of July 31 the Burckhardts had a pleasant dinner with the poet Bill Berkson and his wife. The next day Rudy was simply gone.

Born into a distinguished Basel family (his grandfather had been chief of the Swiss Army; the historian Jacob Burckhardt was another forebear), Rudy realized early on that he wanted to get out of Basel. A chance presented itself in the form of Edwin Denby, an American dancer and later a renowned dance critic, who was passing through and needed someone to take his passport

photo. The two immediately began a lifelong friendship. A modest inheritance allowed Burckhardt to move to New York in 1935, as he once wrote, "looking for the exotic and for sex adventures far from home." Denby and Burckhardt shared a spartan loft on West Twenty-First Street. Soon Rudy was photographing the city and making short films whose actors included Denby's friends Aaron Copland, Virgil Thomson, Paul Bowles, the actor Joseph Cotten, and the handsome young Dutch painter Willem de Kooning, who lived in a loft next door.

I first met Rudy in 1950 when he asked me to play a role in a short, Mack Sennett–like movie (*Mounting Tension*) that also starred my friends the painters Jane Freilicher and Larry Rivers. I was ludicrously miscast as an extrovert baseball player, but that didn't matter: anomalies and accidents nourished Rudy's work. The same is true of his photographs of New York streets, with their groundswells of ever-changing, always-the-same pedestrians in baggy suits and rumpled rayon blouses. Sometimes only a preponderance of two-toned shoes or the advertised price of a milkshake lets us know which decade we are in, but the results are always curiously moving.

According to Yvonne, Rudy rejoiced in the appellation "underground." The fact that painter friends like de Kooning (unknown and impoverished when they first met), Alex Katz, Neil Welliver, and Red Grooms went on to fame and fortune delighted him, not just for their sakes but because he probably felt most comfortable being a walking catalyst and also free to do his thing: *frei aber einsam*,

free but alone, the motto used by several German Romantic composers. He liked it when his films were shown but made no special efforts to promote them. He enjoyed collaborating with young poets of the New York School on small-press books, like his 1979 autobiography, *Mobile Homes*, edited by Kenward Elmslie, or *Boulevard Transportation*, a 1997 collection of his photographs with poems by Vincent Katz.

Least known and perhaps best of all his work are the early paintings of New York, especially the dumb, architecture-free commercial buildings of Lower Manhattan, which he captured long before anybody thought of turning them into expensive living spaces. They gaze vacantly at the viewer, as indifferent to being chronicled as his generic New York pedestrians were. Rudy's work remains remarkable in how despite its total lack of editorializing it is somehow given a fillip by instinctive finesse. As Vincent Katz said: "He gives you / something you see, / not something you / 'should' see."

This Room

The room I entered was a dream of this room.
Surely all those feet on the sofa were mine.
The oval portrait
of a dog was me at an early age.
Something shimmers, something is hushed up.

We had macaroni for lunch every day
except Sunday, when a small quail was induced
to be served to us. Why do I tell you these things?
You are not even here.

On Lynn Davis
2000

When the first traveler-photographers of the nineteenth century began bringing back and displaying their finds in the capitals of Europe and America, their audiences must have found these artifacts doubly puzzling. First there were the subjects themselves: the Pyramids, Karnak, Yosemite, the Taj Mahal, the Dead Sea, in all their awkward, unapologetic grandeur. But probably even more startling was photography itself. This new, ill-understood medium for seizing on the "wonders of the world" was itself one. In a few short decades, of course, every family would have its Kodak, and snapshots of the Sphinx with Aunt Clara in the foreground would be a feature of every parlor. The novelty of photography soon became a commonplace.

Lynn Davis's images take us back to the dawn of epic photography, when the shock of encountering remote sites was compounded by the amazing technical feats that brought them into view, and the dew or pollen of earliness still dappled their surfaces. She has sought out not only extraordinary buildings or monuments whose reason for being is often inscrutable, but also constructions of nature which can seem even more so. An enormous dune in the "empty quarter" of Saudi Arabia whose grandeur and proportions look excessive even considering the geological forces that went into its making, or a vast, solitary iceberg whose presence is as purposefully intimidating as an intact temple far from any human settlement—those are phenomena she has not only

captured but in a sense helped create by isolating them for us to look at.

Her new photographs of contemporary, man-made structures are no less astonishing than the subjects she has been drawn to previously. *Abandoned Missile Site, Cavalier County, North Dakota*, has the Ozymandias-like mystery of some of her desert photographs: only gradually does it dawn on us that this is a recently built and abandoned temple in our own "heartland," and that the Pentagon official responsible for its existence might have meant something far different from Shelley's legendary king if he had bothered to leave the inscription: "Look on my Works, ye Mighty, and despair!"

One might expect a political subtext here, but Davis's work is political only insofar as the act of looking is political. Even though *Very Large Array #2, New Mexico* (and I think I'd just as soon not know what a *Very Large Array* is) seems ominous at first (a vast contraption in the desert whose function is probably military), it immediately turns achingly beautiful—a colossal water lily (or Venus flytrap?) holding itself open to a dark, storm-infused sky that seems about to empty itself into its calyx. A sexual image, too, perhaps, yet why try to stick a label on work that is so various and utterly involving? She has recreated the unconstricted forces of nature (including human nature) that are around us, and made us look at them, and at ourselves with relation to them. Ultimately the experience of her work is perhaps not a comfortable one, but it intoxicates by letting us distinguish the real dimensions of the world we live and think in.

If You Said You Would Come with Me

In town it was very urban but in the country cows were covering the hills. The clouds were near and very moist. I was walking along the pavement with Anna, enjoying the scattered scenery. Suddenly a sound like a deep bell came from behind us. We both turned to look. "It's the words you spoke in the past, coming back to haunt you," Anna explained. "They always do, you know."

Indeed I did. Many times this deep bell-like tone had intruded itself on my thoughts, scrambling them at first, then rearranging them in apple-pie order. "Two crows," the voice seemed to say, "were sitting on a sundial in the God-given sunlight. Then one flew away."

"Yes ... *and then*?" I wanted to ask, but I kept silent. We turned into a courtyard and walked up several flights of stairs to the roof, where a party was in progress. "This is my friend Hans," Anna said by way of introduction. No one paid much attention and several guests moved away to the balustrade to admire the view of orchards and vineyards, approaching their autumn glory. One of the women however came to greet us in a friendly manner. I was wondering if this was a "harvest home," a phrase I had often heard but never understood.

"Welcome to my home ... well, to our home," the woman said gaily. "As you can see, the grapes are being harvested." It seemed she could read my mind. "They say this year's vintage will be a mediocre one, but the sight is lovely, nonetheless. Don't you agree, Mr."

"Hans," I replied curtly. The prospect was indeed a lovely one, but I wanted to leave. Making some excuse I guided Anna by the elbow toward the stairs and we left.

"That wasn't polite of you," she said dryly.

"Honey, I've had enough of people who can read your mind. When I want it done I'll go to a mind reader."

"I happen to be one and I can tell you what you're thinking is false. Listen to what the big bell says: 'We are all strangers on our own turf, in our own time.' You should have paid attention. Now adjustments will have to be made."

On Louisa Matthiasdottir

2000

There are no superfluous secrets in Louisa Matthiasdottir's paintings. The edge of the table in her still lifes is close to the viewer's eye. The tabletop slopes gently upward, its objects placed at some distance from each other so that their individuality remains intact; contiguity doesn't blur their contours and identities. Her pictures of people and animals are almost emblematic. The Icelandic sheep, a rectilinear beast whose double coat of wool hangs down its sides evenly like a horse blanket, seems to have been designed by nature as an illustration on a building block, and the painter emphasizes its two-dimensional squarishness with only a slight trace of humor. Same for her self-portraits: sometimes she paints herself an Icelandic woolen coat of her own, of many colors and broad stripes, with hands on hips and a just-noticeable attitude of impatience: portrait of the artist deciding to do something. Or she will pose in a trench coat and holding a closed umbrella, as stiffly as those eighteenth-century French prints representing various *petits métiers*—this time it's the artist preparing to go outside. This is a story of sorts, not really much of a one, but enough to allow the painter to intervene with a story of another kind involving light, shadows, volumes, and swift, accurate passes with the brush. Then there are the landscapes of Iceland, where she was born and which she has visited regularly through the years. The

land is flat, slanting a little up or down for easy viewing, until it hits the water and then the mountains which block the view, simple and intransigent as the wall behind the table in the still lifes. Apparently there are no trees or sfumato in Iceland. The buildings are simple gabled shapes, white with colored roofs, and few if any windows, like the houses in Monopoly. The land is clean, chilly and open. Sometimes two figures stand in the foreground, not too close together and casting the long shadows one associates with de Chirico. This might seem to invoke a secret or a mystery, but if so it does it only long enough to make the point that this bit of poetry is only a minor ingredient—essential, perhaps, but small—in a game where formal concerns override others without suppressing them.

The cold Nordic colors and an almost summary way with volumes and perspectives are things we remember from expressionism. Are there suggestions of Munch in the bleak urban sunlight, of Hodler in the bald blue mountains, of Marc in the sheep and horses hieratically laced in prismatic air against bold, chromatic planes defined just enough to be constructed as landscape? Probably, but probably they are very few. For all Matthiasdottir's care to bring out the counterpoint of shapes, the armatures and buttresses shoring up the world of appearances, which takes her close to abstraction, she never considers reducing it all to a diagram as did the precisionists, for example. There is an increment of something else, a trace-element of mystery, a dreamlike

tinge, which allows the picture to deploy its loose big shapes and go about its business, just by keeping the whole alive and never letting it sink into facile abstraction or sermon. So, though there are no unnecessary secrets, there are enough—the ones the average person, as opposed to the Machiavellian intriguer, would have. It is just this that gives Matthiasdottir's painting, despite its tendency toward broad simplification, an air of heightened realism—a kind of trompe l'oeil that works on a mental rather than an optical level. In any case, one returns to these pictures, as year after year they paradoxically both expand and simplify the world they have chosen to explore, for their strange flavor, both mellow and astringent, which no other painter gives us.

Signs

It took a long time to reassemble these letters.
Now they are starting to shine.
Look! It says "Noah's Ark."

There must be animals inside,
whiling the listless days away,
battened down on moldy straw.
Some of them are probably seasick
and don't even realize it's for a good cause.

Let's look at these other signs—a cup and saucer,
perched at the edge of a table, creating a 3-D effect.
Or this martini glass, roseate and direct,
playing itself to perfection.

Or the sign of a butter knife, suspended
in a torpid sky, reflected
in the river's chilly waters.
The silhouetted ski lodge—or does this one seem cleaner?

On Jane Freilicher (II)
2001

Throughout her long career, Jane Freilicher has always seemed equally fascinated by the medium she happens to be using and the prospect before her, which is frequently the same one: an interior or exterior view in her studios in New York and Water Mill, Long Island. (Not such a limited one in fact, since it can include the Atlantic Ocean and adjacent Mecox Bay, and the landscape of Lower Manhattan, including glimpses of the Hudson River and the New Jersey heights beyond it, as well as the mysteriously luminous night sky over the city.) Still, her landscapes, like Courbet's forest scenes, seem less interested in conveying a strong sense of genius loci than a general sense of the components of landscape: grass in all its grassiness, trees without the poetry of "Trees" but as objects in the prospect, water that suggests the sweep but not necessarily the skittering surface of, say, Mecox Bay. We have seen such things countless times and don't need to be reminded of how they looked at a specific moment. They are apprehended by Freilicher somewhere between that moment and the generalizations of eternity. Mecox Bay in her painting of it bears a family resemblance to Mecox Bay the place, but the family relationship isn't a very close one—more like that of a first cousin once removed.

This may be due to a democratic urge to avoid the solemnity of "privileged moments" in favor of a feeling for

how nature and objects just keep plugging along—it's that, perhaps, that makes them ultimately important to us. And there is as well her constant awareness of the materials she is using—oil (as here), pastel, charcoal, whatever. The pigment that stands in for water is as much an object of delectation as the water itself. It has to be humored, nudged, helped along to awareness of its materiality even if that means forgetting the subject matter for a moment. Of course she always returns to the subject—one can even sense her taking a few steps backward toward the end of the painting session, squinting to make sure it all checks out and holding the brush horizontally to see how it compares to the horizontality of the horizon. (If they don't quite match, that's okay too.) The end result, for me, is a continual joie de vivre whose source is light breaking out of the canvas, as though it has filled every crevice to overflowing. The painting sings a song of thingness, whether that of the swatch of nature sitting for its portrait or the paint that's helping it to become itself even as it casually poses for its own portrait.

Like Air, Almost

It comes down to
so little:
the gauzy syntax
of one thing and another;
a pleasant dinner
and a frozen train ride into the exhaustible
resources.

We'd had almost enough,
tossing the cap to first one
and then the other one,
but still weren't determined
to give up the drive.
It had so much we wanted!
But besides that, was
fickle, overdetermined.

So I passed on that.
It was worth it.
Angelic eventide came along after afternoon,
a colibri fluttered questioning wings,
all so we might be taken out,
aired.

And when the post-climax happened
in soft shards, falling
this way and that,

singing the night's emeralds away,
we took it to be a sign of something.
"Must be a sign of something."
Then the wind came on, and winter with it.
"Why, weren't we just here,
five minutes ago?"
I thought I'd have another look,
but that way is all changed, and besides,
no one goes there anymore,
it's too popular.

Just one fragment
is all I ever wanted,
but I can have it, it's too much,
but its touch is for another time,
when I'm ready.

Crowd ebbs peacefully.
Hey it's all right.

On Larry Rivers (II)
2002

On August 7, I found myself in an unusual situation—headed for the Hamptons with my friend the playwright and librettist Arnold Weinstein, in a chauffeur-driven town car. Normally I go there by jitney exactly once a year, to visit my friends Joe Hazan and his wife, the painter Jane Freilicher, at which point they throw their annual party. Since my birthday and Labor Day aren't that far apart, it's never entirely clear whether it's a birthday party or a Labor Day party, which makes it easier on those who don't wish to bring a present.

But there would be no party this summer, a summer of sorrow. Less than a month earlier I had made the same trip out to attend a small memorial service for the poet Kenneth Koch, arranged by his wife, Karen, in the garden of their house in Bridgehampton. Kenneth was suddenly given a diagnosis of leukemia in July of last year. Just as it became apparent that his time was finally running out, we heard that Larry Rivers, whose retrospective had recently opened at the Corcoran Gallery of Art in Washington, D.C., was being treated for liver cancer at a hospital in New York.

Nobody knew what his condition was and no visitors were allowed, thanks to controls quickly put in place by Larry's assistant, John Duyck, who was now managing Larry's departure (at seventy-eight) as capably as he had managed most aspects of his life for twenty-three years.

It was John who had broken the news the night before our trip: Larry was back from the hospital but didn't have long to live. He wanted to see friends. John would send a car the next day to pick up Arnold and me for what would surely be our last visit to our great, old, rambunctious friend and occasional adversary.

On the way out, we talked about what we might expect to find. Surely Larry wouldn't have lost his capacity for aggravation, the one constant in his volatile personality. Arnold was bringing Larry a gift, a CD by the jazz saxophonist Ben Webster.

Jazz was Larry's other career; he had begun playing sax with a small outfit in 1945. After a gig in Stockbridge, Massachusetts, a fellow musician announced that the evening's music had been provided by Larry Rivers and his Mudcats. Until then, his name had been Irving Grossberg, though it began as Yitzroch Loiza Grossberg. Briefly there was a third pseudonym which Larry gets wrong in his memoir, *What Did I Do?*, along with about 60 percent of the teeming facts in that fascinating, salacious, and barely readable book. It was Jack Slocum—not Jack Harris, as he reports—a name he adopted for a job drawing customers' portraits to demonstrate a new kind of pen in Hearn's Department Store—not Bloomingdale's—at Christmas, 1953. He did one of me for free—two dollars was a large sum in those days—and, alas, I no longer have it.

When Arnold and I arrived at Larry's modest house, long considered an eyesore by Southampton neighbors,

he greeted us faintly but cheerfully, and with some surprise: no one had told him a parade of friends would begin dropping by. Arnold slipped on the CD and we heard "Tenderly," played in a straightforward, unjazzlike manner. Immediately Larry was alert and kvetching. "He's not playing the tune! That's *not* the tune!"

Knowing next to nothing about jazz, I tried to argue with him: "But isn't that the way jazz is supposed to be?"

"No, it's not the tune! That guy's not playing jazz!"

Arnold and I had trouble suppressing giggles: our contentious pal, master of the unforeseen objection, had outflanked us once again.

After decades of being considered one of America's top avant-garde painters, beginning in the mid-fifties when The Museum of Modern Art bought his outsize *George Washington Crossing the Delaware* and then set the cat among the pigeons by hanging it alongside the cerebral abstractions of Mark Rothko, Barnett Newman, and Philip Guston (Were they trying to send a message? Was abstraction *over*? Wasn't this kitsch?), Larry's critical reputation began a slow decline around 1980. Or, more accurately, critics got bored and moved on to the next big thing. Larry seemed not to notice, or at any rate not to mind. He continued to show at the Marlborough Gallery (an exhibition is scheduled there for next winter), but as a free agent, meaning he could sell his work elsewhere if he wished, and accept the lucrative portrait commissions that often came his way.

Occasionally he would gripe that he had painted flags before Jasper had, or soup cans before Andy, but mostly he ignored the art world and concentrated on making work: big sprawling accumulations like *The History of the Russian Revolution: From Marx to Mayakovsky* (which is at the Corcoran through tomorrow), or a series about Primo Levi, or the series on African animals ("I grew up in the Bronx Zoo," he used to say, and in fact he was born across the street from it), or another series based on Japanese ukiyo-e prints.

Much as he enjoyed a scuffle (like the fist fights with the critic Clement Greenberg, which were almost de rigueur for New York artists in the fifties), he was far more preoccupied with patient investigating and inventing. He could do brilliant pastiches of classic styles of the past: Ingres and Rembrandt as well as the "Dutch Masters" cigar labels derived from Rembrandt, which could morph into the forbidding jowls of Daniel Webster, another cigar-box icon.

His 1968 Velázquez riff, *Silver Infanta*, is to my mind more beautiful than any of Picasso's forays into the same territory. One of my favorites of his "concentrations" is the *Social Patterns* series, based on a cousin's wedding photographs from the thirties, complete with warning that all proofs must be returned, at which time "blemishes, wrinkles, etc. will be removed." Needless to say, Larry ignored the warning and added a lot of "blemishes" of his own. The slick results, suggestive of a still from an Astaire-Rogers film like *Roberta*, are as buoyant and teem-

ing with technical tricks and subtle stylistic juxtapositions as anything he ever did.

Perhaps he was meditating a return to this series, sans the bravura, in his last large painting, which I happened to glimpse in his studio the day I visited him. Apparently done from a photograph, it's a black-and-white oil and charcoal sketch of his family: his wife, Clarice; their daughters, Emma and Gwynne; and Emma's two children, sitting and standing on Clarice's porch and smiling the way people on porches smile for the camera. Clear and candid, it's one of his most beautiful works.

Naturally, in churning out everything from historical *machines* (as the French call labored nineteenth-century storytelling paintings), to portraits of his kids and of wealthy clients, to literally just about anything (another recent group I saw in the studio was a flock of plaster chickens painted crazy colors), he was bound to produce a lot of clunkers along the way, beginning with the early inept-though-touching Bonnard knockoffs that Greenberg had once said were better than Pierre Bonnard, before recanting and saying they "stank." But the sheer volume of masterful work in many mediums (including storm windows, on one of which he once painted a portrait of Jim Dine) is staggering. Critics are going to have a field day tracking down, sorting out, categorizing, and labeling (good luck!) this glittering bonanza of stuff, much of it unseen by anybody. I have a feeling the process may have just begun.

2000

Pierre Boulez—*Sur Incises, Messagesquisse, Anthèmes 2*—Pierre Boulez, Jean-Guihen Queyras, Hae-Sun Kang, Ensemble intercontemporain (Deutsche Grammophon)

William Henry Fry—*Santa Claus Symphony*—Tony Rowe, Royal Scottish National Orchestra (Naxos)

Luigi Nono—*La lontananza nostalgica utopica futura*—Melise Mellinger, Salvatore Sciarrino (KAIROS)

Wolfgang Rihm—*Klavierstück Nr. 6, Nachstudie, Zwiesprache, Auf einem anderen Blatt*—Siegfried Mauser (KAIROS)

Galina Ustvolskaya—*Symphonies 2, 3, 4 & 5*—Oleg Malov, Dmitry Liss, the Saint Petersburg Soloists, Ural Philharmonic Orchestra (Megadisc Classics)

John Zorn—*Cartoon, S&M*—Asko Ensemble, Mondriaan Quartet, Tomoko Mukaiyama, and others (Tzadik)

2001

Gerald Finzi—*A Centenary Collection*—William Boughton, English String Orchestra (Nimbus)

Ernest Chausson—*Le Roi Arthus*—Leon Botstein, American Symphony Orchestra (unpublished recording)

Johannes Brahms, Arnold Schoenberg—*Shadows & Fragments: Brahms and Schoenberg Piano Works*—Sarah Rothenberg (Arabesque)

Milton Babbitt, Jason Eckardt, Michael Finnissy, Jeff Nichols—*American Spiritual*—Marilyn Nonken (CRI)

Antoine Forqueray—*Pièces de Clavecin*—Christophe Rousset (Decca)

Christian Wolff—*Burdocks* (Tzadik)

2002

Gavin Bryars—*Three String Quartets*—The Lyric Quartet (Black Box)

Marc-Antoine Charpentier—*Charpentier!*—Hervé Niquet, Le Concert Spirituel (Glossa)

Franco Donatoni—*Piano Music*—Maria Isabella De Carli (Stradivarius)

Leopold Godowsky—*Sonata, Passacaglia*—Marc-André Hamelin (Hyperion)

Lou Harrison—*Complete Harpsichord Works: Music for Tack Piano & Fortepiano in Historic and Experimental Tunings*—Linda Burman-Hall (New Albion)

Stefan Wolpe—*Compositions for Piano (1920–1952)*—David Holzman (Bridge)

Chinese Whispers

And in a little while we broke under the strain:
Suppurations ad nauseam, the wanting to be taller,
though it's simply about being mysterious, i.e., not taller,
like any tree in any forest.

 Mute, the pancake describes you.
It had tiny Roman numerals embedded in its rim.
It was a pancake clock. They had 'em in those days,
always getting smaller, which is why they finally became
 extinct.
It was a hundred years before anyone noticed.

 The governor-general
called it "sinuous." But we, we had other names for it,
knew it was going to be around for a long time,
even though extinct. And sure as shillelaghs fall from
 trees
onto frozen doorsteps, it came round again
when all memory of it had been expunged
 from the common brain.
Everybody wants to try one of those new pancake clocks.
A boyfriend in the next town had one
but conveniently forgot to bring it over each time we
 invited him.
Finally the rumors grew more fabulous than the real thing:
I hear they are encrusted with tangles of briar rose,
 so dense
not even a prince seeking the Sleeping Beauty could
 get inside.

What's more, there are more of them than when they
 were extinct,
yet the prices keep on rising. They have them in the
 Hesperides
and in shantytowns on the edge of the known world,
blue with cold. All downtowns used to feature them.
 Camera obscuras,
too, were big that year. But why is it that with so many
 people
who want to know what a shout is about, nobody can
 find the original recipe?
All too soon, no one cares. We go back to doing little
 things for each other,
pasting stamps together to form a tiny train track, and
 other,
less noticeable things. The past is forgotten till next time.
How to describe the years? Some were like blocks of the
 palest halvah,
careless of being touched. Some took each other's trash
 out,
put each other's eyes out. So many got thrown out
before anyone noticed, it was like a chiaroscuro
 of collapsing clouds.
How I longed to visit you again in that old house! But you
 were deaf,
or dead. Our letters crossed. A motorboat was ferrying
 me out past
the reef, people on shore looked like dolls fingering
 stuffs.

 More
keeps coming out about the dogs. Surely a simple embrace
from an itinerant fish would have been spurned at
 certain periods. Not now.
There's a famine of years in the land, the women are
 beautiful,
but prematurely old and worn. It doesn't get better. Rocks
 half-buried
in bands of sand, and spontaneous execrations.
 I yell to the ship's front door,
wanting to be taller, and somewhere in the middle all
 this gets lost.
I was a phantom for a day. My friends carried me around
 with them.

It always turns out that much is salvageable.
 Chicken coops
haven't floated away on the flood. Lacemakers are back
 in business
with a vengeance. All the locksmiths had left town during
 the night.
It happened to be a beautiful time of season, spring or fall,
the air was digestible, the fish tied in love knots
on their gurneys. Yes, and journeys

were palpable too: Someone had spoken of saving
 appearances
and the walls were just a little too blue in mid-morning.

Was there ever such a time? I'd like to handle you,
bruise you with kisses for it, yet something always
 stops me short:
the knowledge that this isn't history,
 no matter how many
times we keep mistaking it for the present, that
 headlines
trumpet each day. But behind the unsightly school
 building, now a pickle
warehouse, the true nature of things is known, is not
 overridden:
Yours is a vote like any other. And here is fraud at the
 ballot boxes,
stuffed with lace valentines and fortunes from
 automatic scales,
dispensed with a lofty kind of charity, as though this
 could matter
to us, these tunes
 carried by the wind
from a barrel organ several leagues away. No, this is not
 the time
to reveal your deception to us. Wait till rain and old age
have softened us up a little more.
 Then we'll see how extinct
the various races have become, how the years stand up
to their descriptions, no matter how misleading,
and how long the disbanded armies stay around. I must
 congratulate you
on your detective work, for I am a connoisseur

of close embroidery, though I don't have a diploma to
 show for it.

The trees, the barren trees, have been described more
 than once.
Always they are taller, it seems, and the river passes them
without noticing. We, too, are taller,
our ceilings higher, our walls more tinctured
with telling frescoes, our doorways both airier and vaguer,
according as time passes and weaves its minute
 deceptions in and out,
a secret thread.
Peace is a full stop.
And though we had some chance of slipping past the
 blockade,
now only time will consent to have anything to do with us,
for what purposes we do not know.

On Val Lewton
2003

Like Paris, New York is always ready for its close-up. Somehow the city never fails to look good on the screen, where it quickens excitement the way the place itself does. This is sometimes true even when the film is obviously shot in a studio. The "Riverside Drive" backdrop in an early scene of everybody's favorite cheapo film noir, *Detour*, adds a note of romance, though it is obviously a photograph and a crude one at that. And at least two of Val Lewton's low-budget programmers for RKO, *Cat People* and *The Seventh Victim*, convey a haunting New York ambience, though they were shot thousands of miles away.

Lewton's films, in a genre awkwardly labeled "psychological horror," are cult favorites today, but in their time (the early 1940s) they were considered B movies. Though Lewton was billed as a producer, it was he who imposed a distinctive style on his films. Besides the two mentioned above, *I Walked with a Zombie* and *The Body Snatcher* have become classics of the genre. My favorite, however, is *The Seventh Victim*.

I first heard of it when a fellow Harvard student, Edward Gorey, recounted its plot in his unforgettable delivery, constantly interrupted by strangulated giggles and gasps, a few years after its 1943 release. In those pre-TV and -VCR days, if you missed seeing a B movie when it first came out, you had pretty much lost your chance of ever seeing it. Television, of course, would soon

arrive and begin recycling Hollywood's archives, so that children born after the forties grew up with a cinema literacy that those born in the twenties like me missed out on. It wasn't till the mid-eighties and my first VCR that I was able to buy a commercial VHS cassette of *The Seventh Victim* and find out what Ted Gorey had been gasping about all those years before.

Directed by neophyte Mark Robson (who would go on to commercial fame with the likes of *Peyton Place*, *Valley of the Dolls*, and *Von Ryan's Express*), it tells the eerie saga of young Mary Gibson (the late Kim Hunter in her first role) as she leaves her boarding school to go to New York in search of her older sister, Jacqueline (the obscure Jean Brooks, sporting a dazed expression and Morticia Addams hairdo). After the obligatory, always electrifying logo of the RKO radio tower (accompanied by the opening notes of Beethoven's Fifth Symphony), Roy Webb's angst-laden score (recently released on a CD) surges forth to accompany a quotation from John Donne: "I runne to Death, and Death meets me as fast / And all my pleasures are like yesterday." The opening shot is of a staircase (borrowed from the set of *The Magnificent Ambersons*) at Highcliffe, a boarding school. Mary is confronted by a tide of prattling schoolgirls as she makes her way up to the headmistress's office. The latter explains that Jacqueline is behind with Mary's tuition; Mary says she has been without news of Jacqueline and wants to go to New York to question her associate, Mrs. Redi. The headmistress doubts that she'll learn anything from "that woman," but

gives Mary permission to go, offers to help with her expenses, and says she can always return to school as a teacher. After Mary leaves the office, the headmistress's assistant, Gilchrist, follows her to the staircase and warns her not to come back, saying that she had once been in a similar situation and rued having returned to Highcliffe; she is cut short by the headmistress's angry call of "Gilchrist!" Mary goes down the staircase and out the door, pausing to bestow an affectionate smile on the big grandfather clock in the hall.

This short scene contains a number of the small anomalies that finally make the film such a disorienting experience and contribute to the fascination it has held for its fans (including Carol Reed and Jacques Rivette, who reportedly screened it for the cast of his movie *Duelle*). The headmistress is actually being kind. But her appearance and tone are sinister. We wonder in passing what she knows about "that woman," Mrs. Redi, and how she knows it, though we soon forget this detail as the story unwinds. Nor do we learn why Gilchrist urges Mary to leave, nor why the headmistress summons Gilchrist back with such urgency. (Neither actress appears in the film again.) Mary's affection for the grandfather clock is also unexplained.

We soon learn more about Jacqueline's disappearance and the satanic cult she has become involved with in Greenwich Village, but these mysteries tend to get sidetracked by small discrepancies of plot and motivation, and by erratic strands of dialogue. Tom Conway,

the real-life alcoholic (and brother of George Sanders) who plays Dr. Judd, at one point irrelevantly remarks to a receptionist that he doesn't treat alcoholics: "Dipsomania can be rather sordid." We hear nothing further of dipsomania or the receptionist's problem (her father drinks), but this odd exchange contributes to our sense throughout the film that people are saying anything that comes into their heads, and that the apparent mysteries of the plot are perhaps only a smokescreen for other, ill-defined ones. We gradually get the feeling that the ground under our feet is unstable.

To make matters worse, the original film was cut clumsily to fit into its second-feature slot, adding to the narrative chaos. Some of these cuts are evident; others are not. Natalie (Evelyn Brent), leader and hostess of the sedate devil-worshipping cult that meets in her Greenwich Village duplex for tea and classical music (shades of *Rosemary's Baby*), has only one arm. It has been suggested that missing footage would reveal that she was once a dancer who lost the arm in an accident, which drove her to satanism, but the story seems more engrossing when you don't know this detail.

After arriving in New York, Mary calls on Mrs. Redi, a proper-seeming matron who has taken over Jacqueline's cosmetics factory, La Sagesse ("Wisdom"; its trademark is a satanic emblem). Redi claims not to know Jacqueline's whereabouts, though the latter is in fact being kept prisoner in the factory for having revealed occult secrets to her psychiatrist Dr. Judd and, it turns out, is facing

execution: six other cult members have been similarly condemned and Jacqueline may well become the "seventh victim."

The spiraling complications of the plot take Mary on a scary trip through a studio-bound Manhattan which, as so often, seems more realistic than location filming would have produced. Particularly memorable is the Fourteenth Street station of the IRT subway, where Mary boards a train at night and is soon fleeing from two formally dressed revelers who are supporting the corpse of a murdered man. She dines with a poet, Jason, and a lawyer, Gregory Ward (who turns out to be Jacqueline's husband; he is played by Hugh Beaumont, the future Ward Cleaver of the sixties sitcom *Leave It to Beaver*), in a Perry Street Italian restaurant called the Dante, which features a mural copied from Henry Holiday's famous painting of Dante's first encounter with Beatrice along the Arno. Beatrice in the mural is a dead-ringer for Mary, but, as usual, this coincidence is left unexplored, while red herrings continue to pile up. (A curious one is a scene outside the "Ivy Lane" theater, obviously an allusion to the Village's still-extant Cherry Lane Theater, above which Kim Hunter lived in later life!)

In the film's most famous scene, Mary is confronted in her bathroom shower by Mrs. Redi (brilliantly played by an actress named Mary Newton), who had come to tell her to stop looking for her sister and return to school. While Mary listens naked under the dripping nozzle, Mrs. Redi, wearing a hat and coat, looms as a menacing

shadow against the shower curtain, her voice cold and ominous. (It has been said that Hitchcock, who knew Lewton, got the idea for the shower scene in *Psycho* from this episode.) Eventually Jacqueline is summoned before the assembled Palladists and told she must drink poison from a wineglass. Just as she is about to do so, young Frances, who is loyal to Jacqueline, smashes the glass and bursts into tears. (This cameo is magnificently acted by Isabel Jewell, the hard-boiled blonde in a hundred forgotten and otherwise forgettable B movies.)

Jacqueline is allowed to leave, but told she will soon have to pay the price for her betrayal. A member of the group follows her through the oddly empty streets, at one point seizing her wrist and brandishing a knife. Jacqueline breaks free and makes it back to her room above the Dante. In the final moments of the film, Mary and Ward declare their love for each other, Mary insisting that it can never be consummated on account of Jacqueline. Jacqueline's neighbor Mimi (Elizabeth Russell, who produced a memorable frisson as Simone Simon's nemesis in Lewton's *Cat People*) emerges coughing from her room in evening dress, determined to go out for a last desperate night on the town, just as a thud from Jacqueline's room tells us that she has finally committed suicide with the noose she kept suspended for that eventuality. We hear a woman's voice intoning the Donne couplet that prefaced the film.

Muddled yet marvelous, *The Seventh Victim* is one of the great New York noir movies. (Though it is classified

a horror film, the horror is kept under wraps; as in all the Lewton films, there is barely a splash of gore.) Even though the backgrounds are artificial they have a compelling authenticity. In his 1929 surrealist novel *Hebdomeros*, de Chirico wrote: "A false beard is always more real on the screen than a real beard, just as a wooden and cardboard set is always more real than a natural setting. But try telling that to your film directors, avid for beautiful locations and picturesque views; they won't know what you are talking about, alas!" Despite its second-tier cast and modest production values, *The Seventh Victim*[1] captures the weird poetry of New York in a way that few films have ever done.

1 *The Seventh Victim* (Turner Classics, RKO Collection; VHS, 70 min.).

A Visit to the House of Fools

The year subsides into clouds
more beautiful than any I have seen—
drifting equestrian statues, washing lifted by the wind.
Down here bodies made somber by the cold
meet and diverge at angles. Nothing is given
that may not be retracted. Our fires are glacial,
lighting up the polar backdrop. If you came it
would be in mid-parenthesis now, season of your engaging,
seminar not going anywhere. (I must wall these off;
nothing but a tree would pass here.)

There is no record that some of it was taken out
and later replaced in the file.
The cliff of windows, some lit up, some broken,
allows that variousness will attract
and repel, like a happy ending, the way the truth hurts.

How can "rare earth" be an element?

Test tubes doze. A wide window watches the sea.
Others blow inward toward the room with its floor
like an itch that scratching redeems.
A ruler is pasted against the wall
to tell time by, but it's too late. The snow's
knack for seeking out and penetrating crevices
has finally become major news.
Let's drink to that,
 and the tenacity of just seeming.

On Rudy Burckhardt (II)
2003

At first glance Rudy Burckhardt's photographs of New York in the thirties and forties resemble those of other contemporary documentarians: Dorothea Lange, Russell Lee, John Vachon—even the eccentric Weegee. But Rudy's have less social bite (though that is certainly an element), less wistful poetry (though that is there too), and more sly comedy. The latter is present not only in his candid shots of distracted passersby (a tubby guy in T-shirt and suspenders walking past a storefront announcing that it "will reopen soon, under same management"—is that good?), but also in the crazy geometry of New York. The bland checkerboard tiles in that picture form a witty counterpoint to the man's rotund silhouette. Elsewhere, a pattern of opaque glass tiles in a sidewalk rhymes melodiously with the pattern of circles in a woman's skirt. And sometimes the narrative is purely abstract, like the black-and-white tiled counter of an on-street soft-drink stand surmounted by two erect and very businesslike soda faucets.

Rudy was amused and in love with the haphazard look of things in America, by the ways we have of inventing how to look and walk and talk, by the fanciful nomenclature that comes naturally to us. He used to live near a Chelsea firm called the Atlas Protexit Company, which plays an important role in his film *Mounting Tension*, where a girl mistakenly knocks on Larry Rivers's door

and asks, "Is this the Atlas Protexit Company?" These names pop up throughout his photographs of New York, where signs proclaim the virtues of Fixt Waffles, Jeris Hair Tonic, Mais Oui toiletries, and Blood and Sand Worms (for sale as bait). In one subway scene, an old man seated beneath an ad for Kellogg's All-Bran glares ominously at another man who doesn't see him. There may be a story here, but it's all the better for being barely hinted at.

It's unlikely that many of the harried and abstracted New Yorkers traipsing through these pictures found much that was amusing in their surroundings. For that they would have had to wait for Rudy's version: splendidly wry and witty, but never patronizing, and in fact deeply empathetic and humane. Few other photographers have seen as deeply into the way streets and people look, and been able to report back that the news is good: we're all in this thing together, and that is just as it should be.

The Love Interest

We could see it coming from forever,
then it was simply here, parallel
to the day's walking. By then it was we
who had disappeared, into the tunnel of a book.

Rising late at night, we join the current
of tomorrow's news. Why not? Unlike
some others, we haven't anything to ask for
or borrow. We're just pieces of solid geometry:

cylinders or rhomboids. A certain satisfaction
has been granted us. Sure, we keep coming back
for more—that's part of the "human" aspect
of the parade. And there are darker regions

penciled in, that we should explore some time.
For now it's enough that this day is over.
It brought its load of freshness, dropped it off
and left. As for us, we're still here, aren't we?

On Jane Freilicher (III)
2004

For almost half a century, Jane Freilicher has often painted the views from her studios in Greenwich Village and Water Mill, Long Island. The more she has focused on them, the greater the variations in individual pictures have been. In this she resembles Giacometti or Morandi, two artists whose fanatical determination to "get it right" resulted in what looked like a narrowness of range but was in fact an expansiveness that could have been arrived at in no other way. The same fields, bouquets, slants of light, views out over water or streets and buildings seem to recur, but it is the tremendous difference in them from picture to picture that entraps and enthralls the viewer. This is because she is able to half-forget the subject at hand and concentrate on the sheer pleasure of moving paint around. As she once remarked to James Schuyler in an interview, "I'm interested in landscape, but there's a paradox: it's depressing to get that realistic look: 'Why, that's just the way it looks!' or 'I know that time of day.' ... Of course a landscape goes on forever but a picture doesn't. So very soon it has a composition or a form of its own."[1] She might have said the same of her still lifes, which are often tied to the exterior world by a landscape looming beyond the studio window, or a vase of flowers set on the floor or on the grass outside.

Even a study of a single object can suggest the teeming variousness of a wide prospect. The small 1998 pastel

Flowers on a Table is an example. The colors are low-keyed and matte, the surface dry and scumbled. The flowers look tangled with burrs like the coat of an old sheepdog. What one notices most is a board projecting from the side of the table. What is it doing there? It doesn't look like a table leaf or any other feature of this nondescript piece of furniture, yet the painter insists on it as though it were as important as the bouquet and its brown earthenware jar. It belongs because she noticed it, like the trailers in a corner of the 2001–2002 *Landscape with Construction Site*. They occur because the idyllic field next door is about to be dug up to make room for another bloated Hamptons McMansion, yet, as critic Alex Ross has pointed out, there is nothing judgmental in this: Freilicher paints what is there because it's what is there. Nature is both pretty and ugly, and it happens to include backhoes as well as jacaranda trees. One thinks of the Comtesse de Noailles's injunction to her maid before Vuillard arrived to paint her in bed: "Hide that tube of Vaseline! M. Vuillard paints everything he sees."

An amazing contrast to this casual, almost fuzzy picture is the 1997 still life *At Night*. A terra-cotta planter containing a leathery green plant is placed at the exact center of the canvas on a rectangular base that looks like a gray brick. On either side, equidistant from it, are a blue pitcher and a dark bottle (a medicine bottle?). The tabletop on which they rest is painted a warm, unvariegated yellow. Its farther edge traverses all three containers; behind is a dark urban sky with only a few lights picked out

here and there. This hieratic group accosts the viewer. There is something almost frightening in its symmetry, in the fierce contrast between the shining tabletop and the murky, uncertain night scene beyond. The effect is hallucinatory, as when familiar surroundings are viewed through drug-induced anxiety. Yet at the same time it is serene and lovely; the objects are perhaps merely affirming their status as objects on a table, after all.

New York and the changing skies above it have long been a backdrop in Freilicher's paintings. In 1954 her studio was a cramped tenement apartment in the far East Village; one of the most haunting pictures from that period is a still life of a vase of irises on a windowsill with a rather sinister cityscape behind it culminating in a power plant whose smokestacks are belching black vapor into the moist, early-spring evening sky.

A recent painting, the 2001 *Afternoon in the City*, continues the mood of ambiguous, Baudelairean homage to Manhattan. This is the view from her present studio, which overlooks the West Village, though there are no obvious landmarks: it could be almost anywhere in any city. One telltale detail is the water tower with its conical hat, which is such a common sight in New York that one barely registers it. Do other cities use this system of storing water on the roofs of buildings? I don't remember seeing them elsewhere, and have heard European visitors commenting on them, not altogether favorably. To New Yorkers, I suspect, they seem beautiful, perhaps just because they are part of one's daily environment.

The pathos and grandeur of this small painting, twelve by fourteen inches, are extraordinary. I'm not sure if it was painted before or after September 11, 2001, but the vulnerability that moves us now when we look at the city's skyline is certainly there. Perhaps it was always this way. New York is after all an aggregate of people and buildings that just go on and on until they stop. The hushed moment enshrined here is the product of infinite works and days and the compounds thereof that constitute a life. De Chirico summed it up beautifully in a passage in his novel *Hebdomeros* (translation mine):

> The noise died away; the wind held its breath, the curtains that had billowed romantically at the open windows fell back like flags that the wind no longer lifts. Men in shirtsleeves, who had been playing billiards, suddenly stopped playing as though a great weariness had overtaken them, a weariness for their past life and for the years that still awaited them, with their procession of sad or smiling hours, or simply neutral ones, neither sad nor smiling, just hours, in a word!

The very rich hours that Jane Freilicher carefully celebrates are hours like those.

1 James Schuyler, "The Paintings of Jane Freilicher," *Art and Literature* 10 (Autumn 1966).

For Now

Much will be forgiven those
on whom nothing has dawned. But I wonder,
does our polemic have an axis? And if so,
who does the illuminating? It's not as though I
 haven't stayed,
stinking, in the dark. What does this
particular mess have to do with me, surely
one or more may have wondered. And if he
or she suddenly saw in retrospect
the victimhood of all those years, how pain
was as reversible as pleasure, would they stand
for nothing selling in shops now, the cornucopias
of bargain basements open to the weather?

From pantry and hayloft spiffy white legs
emerge. A way of sitting down
has been established, though it's the same stuff
we groped through before: reeds, old motor-boat
sections, skeins of herring. We brought something else—
some enlightenment we thought the months
might enjoy in their gradual progress through the years:
"sudden realizations," the meaning of dreams
and travel, and how hotel rooms
can become the meaningful space one has always lived in.
It's only a shred, really, a fragment of life
no one else seemed interested in. Not that it can be
 carried away:
It belongs to the décor, the dance, forever.

On Jess

2007

Not coincidentally, the first great comic strip, *Little Nemo*, dealt exclusively with the material of dreams. Nemo's dreams provided the subject matter, and the strips also had the appearance of a dream. Early "funny papers," as they were called, were printed on huge sheets of newsprint in dazzling colors. They were often folded around the outside of the Sunday paper, the better to attract prospective customers. In the case of *Little Nemo*, the pages could suggest a wall or cliff face covered with exotic imagery; the individual frames sometimes formed a grid superimposed on them, as though to contradict the notion of a narrative progression. (Picasso asked Gertrude Stein to save him the comics from American newspapers she read.) There is something intimidating about those vast surfaces teeming with bizarre vignettes, even to the strip's destined reader, a child lying on a rug with the paper safely pinioned under him.

In fact, all comic strips have something dreamlike about them. Like dreams, they recur over and over; the paper will be back next Sunday, and dreams will soon be with us again, no matter how enchanted or scared we were left by the last ones. Jess was of course a fan of comic strips (his *Tricky Cad* parody of Dick Tracy is but one example of his fascination), along with many other kinds of demotic printed imagery. His collages evoke the threatening verticality, clotted with incident, of *Little*

Nemo and other strips, and also their haunting cyclical quality: each, we are given to understand, is but one in a theoretically endless series.

This quality of existing in time as well as on the page is what distinguishes Jess's work from that of other collagists and makes him a great artist. As spellbinding as are the countless details in any given work, what is still more magnetic is its temporal dimension, which is not unlike that of music. This temporality is both visible and fictive, a living entity that extends beyond the margins of the page and into the deepest reaches of consciousness: in Elizabeth Bishop's words, "an undisturbed, unbreathing flame."

Playlist V
2003–2009

2003

Elliott Carter—*The Music of Elliott Carter Volume Five: Nine Compositions (1994–2002)*—Jacob Greenberg, Charles Rosen, Speculum Musicae, and others (Bridge)

Giacinto Scelsi—*Quattro Illustrazioni, Suite No. 8 »Bot-Ba« Cinque Incantesimi*—Markus Hinterhäuser (col legno)

Various—*Arthur Rimbaud: Poètes & Chansons*—Bernard Ascal, Léo Ferré, Colombe Frézin, Patrick Hamel, Patrick Janvier, and others (EPM)

2004

Carlo Gesualdo—*Sacred Music for Easter*—Bo Holten, BBC Singers (BBC Music Magazine)

Reynaldo Hahn—*Piano Quartet, Violin Sonata, and Other Chamber Music*—Room-Music (Hyperion)

Déodat de Séverac—*Scenes of Southern France: Cerdaña, En Languedoc*—Jordi Masó (Naxos)

2005

David Del Tredici, Aaron Jay Kernis—*Out of My Hands*—Anthony de Mare (Koch International Classics)

Elliott Carter—*The Vocal Works (1975–1981)*—Speculum Musicae and others (Bridge)

Charles Ives—*Universe Symphony*—Johnny Reinhard, AFMM Orchestra (Stereo Society)

2006

Charles Koechlin—*Quartets No. 1 & No. 2*—Ardeo Quartet (Mecenat Musical)

Franz Schubert—*21 Schubert Lieder*—Richard King, Susan Teicher (Albany)

Stefan Wolpe—*Wolpe in Jerusalem*—Werner Herbers, Johannes Kalitzke, WDR Sinfonieorchester Köln (Mode)

2007

Béla Bartók, Manuel de Falla, Jean Françaix, Francis Poulenc—*The Composers Play*—Berliner Philharmoniker, Orchestre des Concerts Straram, Orchestre Philharmonique de Paris (Dutton)

Henry Brant, Charles Ives—*A Concord Symphony*—Dennis Russell Davies, Royal Concertgebouw Orchestra (innova)

Sergei Taneyev—*Symphony No. 1 in E minor, Symphony No. 3 in D minor*—Valery Polyansky, Russian State Symphony Orchestra (Chandos)

2008

Pink Martini—*Sympathique* (Heinz)

Vincent d'Indy, Albert Roussel, Florent Schmitt—*Composers Perform Their Own Music, Vol. 1* (Perennial)

Various—*Gramophone Collectors' Edition CD No. 24: Bostridge on Britten*—Renée Flemming, Pierre-Laurent Aimard, Gerald Finley, and others (Gramophone Magazine)

2009

Charles Koechlin—*Piano Quintet Op. 80, Quartet No. 3 Op. 72*—Sarah Lavaud, Antigone Quartet (AR RE-SE)

Giacinto Scelsi—*Quattro Illustrazioni, Xnoybis, Cinque Incantesimi, Duo Pour Violon et Violoncelle*—Suzanne Fournier, Carmen Fournier, David Simpson (Accord)

Christian Wolff—*Long Piano*—Thomas Schultz (New World)

Uptick

We were sitting there, and
I made a joke about how
it doesn't dovetail: time,
one minute running out
faster then the one in front
it catches up to.
That way, I said,
there can be no waste.
Waste is virtually eliminated.

To come back for a few hours to
the present subject, a painting,
looking like it was seen,
half turning around, slightly apprehensive,
but it has to pay attention
to what's up ahead: a vision.
Therefore poetry dissolves in
brilliant moisture and reads us
to us.
A faint notion. Too many words,
but precious.

JOHN ASHBERY was born in Rochester, New York, in 1927. He earned degrees from Harvard and Columbia, and went to France as a Fulbright Scholar in 1955, living there for much of the next decade. His many collections of poetry include *Commotion of the Birds* (2016), *Breezeway* (2015), *Quick Question* (2012), *Planisphere* (2009), and *Notes from the Air: Selected Later Poems* (2007), which was awarded the 2008 International Griffin Poetry Prize. *Self-Portrait in a Convex Mirror* (1975) won the three major American prizes—the Pulitzer Prize, the National Book Award, and the National Book Critics Circle Award—and the early book *Some Trees* (1956) was selected by W. H. Auden for the Yale Younger Poets Series. The Library of America published two volumes of his collected poems (*1956–1987* in 2008 and *1991–2000* in 2017), and Ashbery was the first living poet to be included in the series. A two-volume set of his translations from the French (poetry and prose) was published in 2014. Active in various areas of the arts throughout his career, he served as executive editor of *ARTnews* and as art critic for *New York* magazine and *Newsweek*. He had several exhibitions of his collages at Tibor de Nagy Gallery, which represents his estate, and a book of his collages with a selection of his poems was published by Rizzoli in 2018. Ashbery taught for many years at Brooklyn College (CUNY) and Bard College, and from 1989 to 1990 delivered the Charles Eliot Norton lectures at Harvard, published as *Other Traditions* (2000). He was a member of the American Academy of Arts and Letters (receiving its Gold

Medal for Poetry in 1997) and the American Academy of Arts and Sciences, and was a chancellor of the Academy of American Poets from 1988 to 1999. The winner of many prizes and awards both nationally and internationally, he received two Guggenheim Fellowships and was a MacArthur Fellow from 1985 to 1990. He was awarded the Medal for Distinguished Contribution to American Letters from the National Book Foundation (2011) and a National Humanities Medal, presented by President Barack Obama at the White House (2012). His work has been translated into more than twenty-five languages. He collaborated with filmmakers, composers, visual artists, and writers. Ashbery died in September 2017 at the age of ninety. His work continues to inspire countless creative artists in many fields. Additional information is available in the "About John Ashbery" section of the Ashbery Resource Center's website, a project of The Flow Chart Foundation, www.flowchartfoundation.org/arc.

MÓNICA DE LA TORRE is a poet and essayist. Her books include *Repetition Nineteen* (2020) and *The Happy End / All Welcome* (2017), a riff on Martin Kippenberger's 1994 art installation *The Happy End of Franz Kafka's "Amerika,"* itself a riff on Kafka's unfinished novel *Amerika*. Born and raised in Mexico City, she is also the author of several collections in Spanish, including the image-text volume *Taller de Taquimecanografía* (2011), an exquisite corpse composed with the eponymous women's art collective she helped form. She is the recipient of a 2022 Creative Capital Award and a Foundation for Contemporary Arts C. D. Wright Award for Poetry. She coedited the anthology *Women in Concrete Poetry 1959–1979* (2020) and teaches at Brooklyn College.

JEFFREY LEPENDORF is a musician, performer, and visual artist. He has performed, and his music has been performed, around the globe, literally: a recording of his "Night Pond" for solo *shakuhachi* was launched into space on the Atlantis shuttle and remained for a year aboard the Mir space station. His *Masterpieces of Western Music* audio course is available through audible.com. He has received numerous grants and awards and his work has appeared in *A Public Space*, *jubilat*, *PEN America*, and elsewhere. A nationally recognized nonprofit arts leader, he currently serves as the executive director of The Flow Chart Foundation, which opens new possibilities by exploring poetry and the interrelationships of various art forms as guided by the legacy of John Ashbery.

A NOTE ON THE TEXTS

We have striven to respect John Ashbery's original texts as much as possible. All poems in this volume appear as they did in their first collected form. As Ashbery's late art writings were published over many years across various types of publications, we have standardized spellings and capitalization and have made slight modifications to punctuation for greater readability and consistency.

ORIGINAL PUBLICATION INFORMATION

Most of John Ashbery's late art writings reproduced in this volume are untitled. If they were originally published with a title, it is indicated below. All late art writings in this volume are reproduced from their first published form, unless otherwise indicated. Many of Ashbery's poems were first published in literary magazines and other printed matter. All poems reproduced in this volume come from their first collected form.

ART WRITINGS

"As a child I always wanted …" was first published in *Literary Vision*. Exh. cat. (New York: Jack Tilton Gallery, 1988).

"On Rodrigo Moynihan" was first published in *Rodrigo Moynihan: Paintings and Works on Paper*, ed. Richard Shone (London: Thames and Hudson, 1988).

"On Yves Tanguy" was first published as "Yves Tanguy" in *Twentieth-Century Modern Masters: The Jacques and Natasha Gelman Collection*, ed. William S. Lieberman. Exh. cat. (New York: The Metropolitan Museum of Art, 1989).

"On Frank Faulkner" was first published as "Frank Faulkner" in *Frank Faulkner: New Paintings*. Exh. cat. (New York: Associated American Artists, 1990).

"On Ellsworth Kelly" was first published in *Ellsworth Kelly: Plant Drawings*. Exh. cat. (New York: Matthew Marks Gallery, 1992).

"On Larry Rivers (I)" was first published in *Larry Rivers: Art and the Artist*. Exh. cat. (New York: Marlborough Gallery, 1993).

"On Joan Mitchell" was first published in *Joan Mitchell 1992*. Exh. cat. (New York: Robert Miller Gallery, 1993).

"On Jane Freilicher (I)" was first published in *Jane Freilicher*. Exh. cat. (New York: Fischbach Gallery, 1995).

"On Robert Mapplethorpe" was first published in *Pistils* (New York: Random House, 1996). The text reproduced in this volume is taken from *John Ashbery: Selected Prose*, ed. Eugene Richie (Ann Arbor: University of Michigan Press, 2004). Note Ashbery made minor adjustments to the text for its publication in *Selected Prose*.

"On Joe Brainard" was first published in *Joe Brainard: A Retrospective*. Exh. cat. (New York: Tibor de Nagy Gallery, 1997). The text reproduced in this volume is taken from *John Ashbery: Selected Prose*, ed. Eugene Richie (Ann Arbor: University of Michigan Press, 2004).

"On Trevor Winkfield" was first published in *Trevor Winkfield's Pageant*. Exh. cat. (West Stockbridge, MA: Hard

Press, 1997). The text reproduced in this volume is taken from *John Ashbery: Selected Prose*, ed. Eugene Richie (Ann Arbor: University of Michigan Press, 2004).

"On Rudy Burckhardt (I)" was first published as "The Enabler" in *The New York Times Magazine*, January 2, 2000.

"On Lynn Davis" was first published in *Lynn Davis*. Exh. cat. (New York: Edwynn Houk Gallery, 2000).

"On Louisa Matthiasdottir" was first published in *Louisa Matthiasdottir*. Exh. cat. (New York: Hudson Hills, 2000).

"On Jane Freilicher (II)" was first published as "On Jane Freilicher's *View over Mecox (Yellow Wall)*" in *Voices in the Gallery: Writers on Art*, ed. Grant Holcomb (Rochester, NY: University of Rochester Press, 2001). The text reproduced in this volume is taken from *John Ashbery: Selected Prose*, ed. Eugene Richie (Ann Arbor: University of Michigan Press, 2004).

"On Larry Rivers (II)" was first published as "Larry Rivers Was Dying. He Asked to See Friends," *The New York Times*, August 25, 2002. The text reproduced in this volume is taken from *John Ashbery: Selected Prose*, ed. Eugene Richie (Ann Arbor: University of Michigan Press, 2004).

"On Val Lewton" was first published as "On Val Lewton's *The Seventh Victim*" in *Modern Painters*, Autumn 2003. The

text reproduced in this volume is taken from *John Ashbery: Selected Prose*, ed. Eugene Richie (Ann Arbor: University of Michigan Press, 2004).

"On Rudy Burckhardt (II)" was first published as "New York? Mais Oui!: Rudy Burckhardt" in *Rudy Burckhardt: New York Photographs*. Exh. cat. (New York: Tibor de Nagy Gallery, 2003). The text reproduced in this volume is taken from *John Ashbery: Selected Prose*, ed. Eugene Richie (Ann Arbor: University of Michigan Press, 2004).

"On Jane Freilicher (III)" was first published as "Work and Days" in *Jane Freilicher* (New York: Abrams, 2004).

"On Jess" was first published in *Jess: To and From the Printed Page*. Exh. cat. (New York: Independent Curators International, 2007).

"Vetiver" and "Life as a Book That Has Been Put Down" were first collected in *April Galleons: Poems* (New York: Viking, 1987).

Flow Chart was first published in 1991 by Alfred A. Knopf, New York.

"Light Turnouts" and "From Estuaries, from Casinos" were first collected in *Hotel Lautréamont* (New York: Alfred A. Knopf, 1992).

"Mutt and Jeff" and "The Improvement" were first collected in *And the Stars Were Shining: Poems* (New York: Farrar, Straus and Giroux, 1994).

"No Longer Very Clear" was first collected in *Can You Hear, Bird: Poems* (New York: Farrar, Straus and Giroux, 1995).

"Wakefulness" and "Moderately" were first collected in *Wakefulness: Poems* (New York: Farrar, Straus and Giroux, 1998).

Girls on the Run was first published in 1999 by Farrar, Straus and Giroux, New York.

"This Room" and "If You Said You Would Come with Me" were first collected in *Your Name Here: Poems* (New York: Farrar, Straus and Giroux, 2000).

"Signs" was first collected in *As Umbrellas Follow Rain* (Lenox, MA: Qua Books, 2001).

"Like Air, Almost" and "Chinese Whispers" were first collected in *Chinese Whispers: Poems* (New York: Farrar, Straus and Giroux, 2002).

"A Visit to the House of Fools" and "The Love Interest" were first collected in *Where Shall I Wander: New Poems* (New York: Ecco, 2005).

"For Now" was first collected in *A Worldly Country: New Poems* (New York: Ecco, 2007).

"Uptick" was first collected in *Planisphere: New Poems* (New York: Ecco, 2009).

"Ekphrasis" is traditionally defined as the literary representation of a work of visual art. One of the oldest forms of writing, it originated in ancient Greece, where it referred to the practice and skill of presenting artworks through vivid, highly detailed accounts. Today, "ekphrasis" is more openly interpreted as one art form, whether it be writing, visual art, music, or film, that is used to define and describe another art form, in order to bring to an audience the experiential and visceral impact of the subject.

The *ekphrasis* series from David Zwirner Books is dedicated to publishing rare, out-of-print, and newly commissioned texts as accessible paperback volumes. It is part of David Zwirner Books's ongoing effort to publish new and surprising pieces of writing on visual culture.

OTHER TITLES IN THE *EKPHRASIS* SERIES

On Contemporary Art
César Aira

The Salon of 1846
Charles Baudelaire

A Balthus Notebook
Guy Davenport

Ramblings of a Wannabe Painter
Paul Gauguin

Thrust: A Spasmodic Pictorial History of the Codpiece in Art
Michael Glover

Visions and Ecstasies
H.D.

Pissing Figures 1280–2014
Jean-Claude Lebensztejn

The Psychology of an Art Writer
Vernon Lee

Degas and His Model
Alice Michel

28 Paradises
Patrick Modiano and
Dominique Zehrfuss

Summoning Pearl Harbor
Alexander Nemerov

Chardin and Rembrandt
Marcel Proust

Letters to a Young Painter
Rainer Maria Rilke

The Cathedral Is Dying
Auguste Rodin

Giotto and His Works in Padua
John Ruskin

Duchamp's Last Day
Donald Shambroom

Dix Portraits
Gertrude Stein

Photography and Belief
David Levi Strauss

The Critic as Artist
Oscar Wilde

Oh, to Be a Painter!
Virginia Woolf

Two Cities
Cynthia Zarin

FORTHCOMING IN 2022

Strange Impressions
Romaine Brooks

Kandinsky: Incarnating Beauty
Alexandre Kojève

Something Close to Music
John Ashbery

Published by
David Zwirner Books
529 West 20th Street, 2nd Floor
New York, New York 10011
+ 1 212 727 2070
davidzwirnerbooks.com

Managing Director: Doro Globus
Editorial Director: Lucas Zwirner
Head of Production: Jules Thomson
Sales and Distribution Manager:
Molly Stein
Publishing Assistant: Joey Young

Project Editor: Elizabeth Gordon
Proofreader: Jessica Palinski
Design: Michael Dyer / Remake
Production Manager: Claire Bidwell
Printing: VeronaLibri, Verona

Typefaces: Arnhem, Antique Legacy
Paper: Holmen Book Cream, 80 gsm

Distributed in the United States
and Canada by
Simon & Schuster, Inc.
1230 Avenue of the Americas
New York, New York 10020
simonandschuster.com

Distributed outside the United States
and Canada by
Thames & Hudson, Ltd.
181A High Holborn
London WC1V 7QX
thamesandhudson.com

ISBN 978-1-64423-070-1

Library of Congress Control
Number: 2021925058

Printed in Italy

Many thanks to David Kermani
and The Flow Chart Foundation for
their collaboration and support.